JULIA MARGARET CAMERON

PHOTOGRAPHS

from

THE J. PAUL GETTY MUSEUM

The J. Paul Getty Museum

Los Angeles

In Focus
Photographs from the J. Paul Getty Museum
Weston Naef, *General Editor*

© 1996 The J. Paul Getty Museum

Getty Publications
1200 Getty Center Drive, Suite 500
Los Angeles, California 90049-1682
www.getty.edu

Christopher Hudson, *Publisher*
Mark Greenberg, *Editor in Chief*

Third printing 2002

Library of Congress
Cataloging-in-Publication Data

Cameron, Julia Margaret Pattle, 1815–1879.
 Julia Margaret Cameron : photographs from the
J. Paul Getty Museum.
 p. cm. — (In focus)
 ISBN 0-89236-374-6
 1. Photography, Artistic. 2. Portrait photography.
3. Cameron, Julia Margaret Pattle, 1815–1879.
4. J. Paul Getty Museum—Photography collections.
5. Photography collections—California—Malibu.
I. J. Paul Getty Museum II. Title. III. Series: In
focus (J. Paul Getty Museum)
TR652.C35 1996
779'.2'092—dc20 95-48250
 CIP

Contents

Foreword

This is the first In Focus book devoted to a nineteenth-century artist. Julia Margaret Cameron has a logical claim to precedence. Beyond being the maker of a large body of photographs that ranks among the Getty Museum's finest holdings, Cameron is a historical figure of consuming interest. In mid-life she seized upon photography with a passion. Under primitive conditions, with limited resources, in only sixteen years, she made more than three thousand pictures.

Cameron's work was the subject of the first exhibition held in a new gallery devoted to photographs in 1986 and of our first book on photography—*Whisper of the Muse: The Overstone Album and Other Photographs by Julia Margaret Cameron,* by Mike Weaver. We have continued to buy important pictures by Cameron, and having seen the collection acquire a satisfying shape, we believed it was time to present a wider selection of her images.

Cameron's life and work were discussed in a colloquium held at the Getty Museum on June 2, 1995. The participants included Judy Dater, Joanne Lukitsh, Weston Naef, Pamela Roberts, and Robert Woof, as well as Julian Cox, the organizer, and David Featherstone, the moderator and condenser of the transcript.

I want especially to thank Julian Cox for his role in managing this project as well as for providing the interpretive texts for the plates. Many others were involved: Gordon Baldwin, Stepheny Dirden, Michael Hargraves, Marc Harnly, Andrea Leonard, Charles Passela, Ellen Rosenbery, Jean Smeader, Rebecca Vera-Martinez, and Katherine Ware. Various pieces of helpful information about Cameron and her work were contributed by Joan Corcoran, Violet Hamilton, Colin Harding, Kathleen Howe, Carol Mavor, Laura Muir, Ann Paterra, Joseph Struble, Roger Taylor, Leonard and Marjorie Vernon, and Michael and Jane Wilson, whom I am glad to thank. To Weston Naef, inspirer and editor of this In Focus series, I am especially grateful.

John Walsh, *Director*

Introduction

J ulia Margaret Cameron (1815–79) was born in Calcutta, the fourth child of James and Adeline de l'Etang Pattle. She was one of the seven celebrated Pattle sisters, renowned in Anglo-Indian society for their intelligence and beauty. In 1838 she married Charles Hay Cameron, a distinguished jurist and legal reformer, with whom she had six children. The family was prominent in Calcutta society and assumed a similar position after moving to England in 1848 upon Charles Cameron's retirement. Three of the Pattle sisters had already settled there, and together they created a stir in London society. Anne Thackeray Ritchie described her first impression of them: "To see one of this sisterhood float into a room with sweeping robes and falling folds was almost an event in itself. . . . They had unconventional rules for life which excellently suited themselves, and which also interested and stimulated other people. They were unconscious artists, divining beauty and living with it."

Cameron first revealed her creative verve in effusive literary correspondence with family and friends. Her letters express a constant preoccupation with beauty and a fascination for the nuances of the natural world. By the time she took up photography, after receiving a camera as a gift late in 1863, she was a mature woman with a passion for literature and the visual arts who ruled her household and could work effectively from within a domestic structure.

In an 1857 *Quarterly Review* article analyzing the status of photography as an art, the critic and commentator Lady Elizabeth Eastlake suggested that "for all that requires manual correctness, and mere manual slavery, without any employment of the artistic feeling, she [photography] is the proper and therefore the perfect medium." Cameron's approach counteracted this position. She believed passionately in the idealizing and transformative power of art and found in the camera a tool of expression that could be used to harness her "deeply seated love of the beautiful." With the full force of her extraordinary will, Cameron set out to create photographs consistent with the aims of art: "My aspirations are to ennoble Photography and to secure for it the character and uses of High Art by combining the real and Ideal and sacrificing nothing of the Truth by all possible devotion to Poetry and beauty."

Cameron's imagery was revolutionary, and in part this led to her being evaluated in gendered terms by critics in the photographic press. While her portraits of eminent men received acclaim, they were not considered the equal of those by her teacher David Wilkie Wynfield on the grounds that "her artistic knowledge is inferior to that which is the chief characteristic of those produced by her master." Cameron's photographs were applauded as "bold" and "expressive" but faulted for their technical imperfections. Her rejection of conventional focus, in favor of suggestion and approximation, ran contrary to the prevailing Victorian taste for verisimilitude. Moreover, she took unfashionable delight in the chance behavior of photochemistry and produced an eclectic range of prints in plum, auburn, and russet shades, which bring the works closer to paintings.

In the face of such barbed criticism, Cameron was an enthusiastic promoter of her own cause. She was related by blood, friendship, and social ties to many influential people in Victorian society, and she used this intricate support system to help advance the audience for her art. She exhibited tirelessly and from 1864 on sold her photographs through Colnaghi's, an art gallery that was also the most prominent London agent in the field of photographic publishing. Friends were lobbied to review her work in leading journals, as much to help generate sales as to promote recognition of her facility in the "divine art." She was the first photographer who consistently took advantage of the Copyright Bill of 1862, which recognized photography as a graphic medium entitled to the protection of the law.

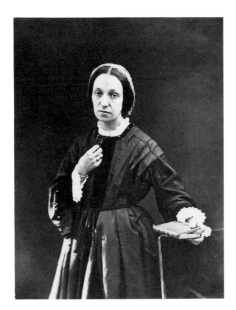

Lord Somers. *Julia Margaret Cameron,* circa 1862.
Albumen print, 13.2 × 9.9 cm.
Michael and Jane Wilson Collection.

Copyrighting required the registration of each picture at Stationer's Hall in London for a charge of one shilling; this decreed the author the sole and exclusive right of copying, reproducing, or otherwise multiplying the photographic print and its negative. Between 1864 and 1875 Cameron registered 505 photographs, an indication of her commitment to the work and ambition for commercial gain. She had copy negatives made of her more successful pictures; these were printed in the carbon process by the Autotype Company in London. A selection of her images was also available in the popular *carte-de-visite* and cabinet card formats, but their dimensions were ill suited to the grand scale of her compositions.

The Getty Museum's collection of Cameron photographs consists of 302 prints acquired over the past twelve years from various sources, including Samuel Wagstaff, Jr., Daniel Wolf, André Jammes, Michael Wilson, Bruno Bischofberger, and Cameron's descendants. This total comprises an album of 112 photographs presented by the artist to Lord Overstone on August 5, 1865; 138 individual prints;

and 52 pictures that form a double set of Cameron's two-volume *Illustrations to Tennyson's "Idylls of the King" and Other Poems*. The Overstone Album represents the core of the Museum's holdings; it contains some of the finest images from Cameron's first two years of work. Important pictures have been bought individually and in groups to complement the album and to reflect the diverse array of subjects and sitters that occupied the artist throughout her career.

The plates in this book have been selected to profile the manifold aspects of Cameron's art. She frequently inscribed on the mounts of her prints variants of the phrases "from life, registered photograph, copyright" and titled each work in her flowing script. Her inscriptions provide clues as to her intentions and demonstrate a desire that her audience understand and embrace her subjects. She also fastidiously trimmed her prints to oval, tondo, and dome shapes for sale and presentation in albums, a step that involved a considerable sacrifice of time and labor.

Following the plate section is an edited transcript of a 1995 colloquium on Cameron's life and work that was held at the Getty Museum. Each of the participants contributed his or her own blend of knowledge and insight regarding the artist's work. Judy Dater is a photographer based in Palo Alto, California, who has admired Cameron's pictures for many years. Joanne Lukitsh, an Assistant Professor at the Massachusetts College of Art, prepared the 1986 exhibition and publication *Cameron: Her Work and Career* for the International Museum of Photography at George Eastman House. Weston Naef, Curator of Photographs at the Getty Museum, acquired the Overstone Album and other Cameron photographs for the institution. Pamela Roberts is Curator of the Royal Photographic Society, Bath, England, which houses the largest group of Cameron photographs in the world. In 1991 she collaborated in the preparation of the exhibition and publication *Whisper of the Muse: The World of Julia Margaret Cameron,* organized by Colnaghi's, London. Robert Woof is Director of the Wordsworth Trust and Centre for British Romanticism, Grasmere, England, and has published on the literature and arts of the late eighteenth and early nineteenth century. David Featherstone, an independent editor and writer who lives in San Francisco, served as the colloquium moderator and transcript editor.

Julian Cox, *Assistant Curator, Department of Photographs*

8

Plates

A Note about Inscriptions

Cameron commonly inscribed the mounts of her prints with a title, descriptive phrases, and her signature. Plates 1 and 17 reproduce both the print and the mount to provide examples of this practice.

PLATE I

Annie

January 1864

Albumen print
18 × 14.3 cm
84.XZ.186.69

In December 1863 Julia Margaret Cameron received from her only daughter, Julia, and her son-in-law, Charles Norman, the gift of a wooden box camera. She was forty-eight years old, a woman whose prodigious energies had been centered on raising her six children. Now, with her daughter married and her husband and three eldest sons away on the family coffee estates in Ceylon, she found herself at a transitional moment in her life. Taking up photography at this time, she began, in her own words, "to arrest all beauty that came before me."

Cameron's retrospective written account of her career in photography, *Annals of My Glass House* (penned in 1874 and published posthumously in 1889), stresses the solitary nature of her early experiments: "I began with no knowledge of the art. I did not know where to place my dark box, how to focus my sitter, and my first picture I effaced to my consternation by rubbing my hand over the filmy side of the glass." Despite this proclamation, Cameron may have already learned the basics of camera operation and chemistry from Oscar Gustave Rejlander, with whom she shared many mutual friends, most importantly Alfred Tennyson, her neighbor on the Isle of Wight. Another likely early tutor was her brother-in-law Lord Somers, an accomplished amateur photographer who made portraits of Cameron's family circle.

After at least a month of experimentation in the January cold of her studio at her home in Freshwater, Cameron created a portrait that she was proud to declare as "My very first success in Photography," words she inscribed on the mount of this print. Her subject was Annie Philpot, the daughter of a local resident. It is a picture of great simplicity and grace, conspicuously divided in terms of light and dark. This particular print was carefully trimmed for presentation in the album given to Lord Overstone in 1865.

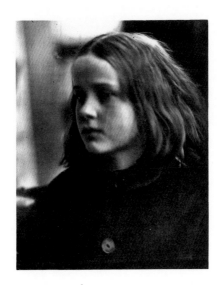

Annie

My very first success in Photography
January 1864

PLATE 2

Sadness

1864

Albumen print
22.1 × 17.5 cm
84.XZ.186.52

Within a month of her "very first success" (pl. 1), Cameron had created a presentation album for her close friend, the painter George Frederick Watts. The album (now at the International Museum of Photography at George Eastman House), inscribed to Watts and dated February 22, 1864, contains thirty-nine of Cameron's earliest photographs. It was some time very close to this date that she created the negative for *Sadness*, a study of the Shakespearean actress Ellen Terry.

Terry came from a theatrical family and had her stage debut at age nine. In 1862 she was introduced to Watts, who painted a double portrait of her with her elder sister Kate. In a union engineered by the Pattle sisters, Terry and Watts were married in February 1864, when she was just sixteen. Within a year the couple had separated; they were formally divorced in 1877.

The pair spent their honeymoon at Freshwater, and most likely it was at this time that the portrait was made. While the possibility exists that Terry, as an actress, was striking a pose for Cameron, the picture's title suggests the realization of a mismatched marriage. Terry's anxiety is plainly evident—she leans against an interior wall and tugs nervously at her necklace. The lighting is notably subdued, leaving her face shadowed in doubt. In *The Story of My Life* (1908), Terry recalls how demanding Watts was, calling upon her to sit for hours as a model and giving her strict orders not to speak in front of distinguished guests in his studio.

Cameron's uncertain technique is evidenced by the image loss at the lower center of the picture, where the collodion emulsion peeled away from the glass-plate negative. She must have created only a single negative at this sitting, since she presented the picture as is in the Overstone Album. The negative was later rephotographed (with the damage repaired) and distributed commercially as a carbon print by the Autotype Company of London (p. 111). This later version was reproduced in 1913 in Alfred Stieglitz's *Camera Work*.

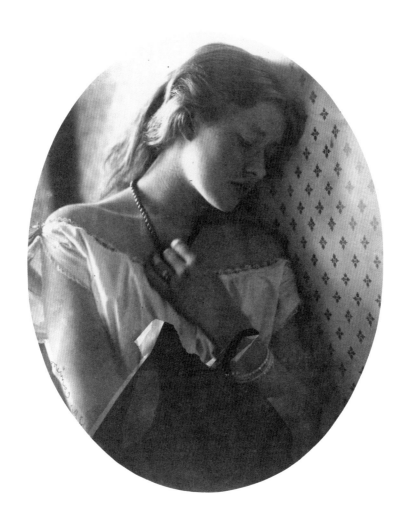

PLATE 3

Charles Hay
Cameron

1864

Albumen print
29.1 × 22.3 cm
84.XZ.186.78

Charles Hay Cameron, once described by Tennyson as "a philosopher with his beard dipped in moonlight," was educated at Eton College and Oxford University. An accomplished scholar, he had a highly distinguished career as a civil servant in the judiciary in India. He was fiercely devoted to legal reform and a proponent of education in the colonies. In 1835 he was elected as the British member on the Indian Law Commission and while in Calcutta served on the Supreme Council of India. He pursued his scholarly work without the benefit of institutional support, an example that surely stimulated his wife's endeavors.

When Cameron met her future husband in 1835, he was writing his "Essay on the Sublime and Beautiful," a thoughtful text that explores many of the concepts that were to be fundamental to her art. The aesthetics of the human figure, the interrelationship of sight and touch in the creation of works of art, and the metaphysical properties of language are some of the issues that are discussed.

When he retired to the Isle of Wight in 1860, Charles Cameron led a sedentary existence, withdrawing from the customary throng of household visitors to the isolation of his bedchamber and the solace of Homer, Virgil, Shakespeare, Milton, and Keats. He was photographed only on a few occasions by his wife, most notably when he performed the roles of King Lear and Merlin in her illustrations for Tennyson's *Idylls of the King*.

In this early portrait Cameron chose to picture her husband in an engaging, frontal pose, seated in an armchair in his overcoat, bathed in dramatic side lighting. The grandiose and yet tender nature of the study recalls the sentiments expressed by Cameron toward him in a prayer she wrote in 1838, when quickened with her first child: "Most blessed Lord . . . Thou alone dost know how fondly dear This my husband is to me, how great is his tenderness, how true is his love."

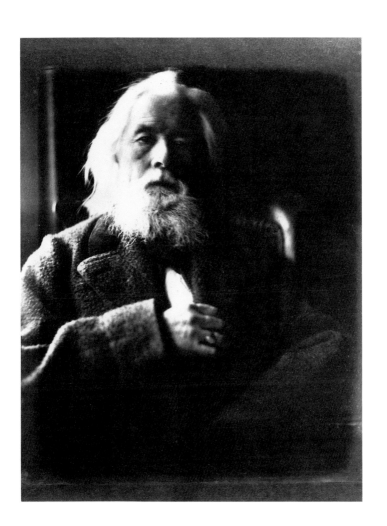

PLATE 4

Hardinge Hay Cameron

May 1864

Albumen print
24.9 × 19.5 cm
84.XZ.186.9

In his influential 1859 publication *Self-Help,* Samuel Smiles described the home as "the very nucleus of national character; and from that source . . . issue the habits, principles and maxims, which govern public as well as private life." For Cameron, family life formed the cornerstone of her art. Her five sons were all pressed into service before the camera and often helped in practical matters. Describing her earliest experiments in her *Annals,* Cameron remarked: "Hardinge, being on his Oxford vacation, helped me in the difficulty of focussing," practical advice that contributed to her "first success" with *Annie* (pl. 1).

In this 1864 portrait, Hardinge, the third son, is presented in the guise of an artist. The style of presentation is Titianesque—the lighting is somber and moody, creating the very faintest of modeling in the skin tones, so that the subject's facial features are clothed in a subdued, painterly chiaroscuro. The practice of dressing up and assuming a role was familiar to the Cameron children on account of the elaborate amateur theatricals that took place in their house, Dimbola, and at Farringford, the home of the neighboring Tennysons. Cameron has taken this role-playing a step further and ennobled it with the camera, combining in pictorial form the real and ideal.

The mannerism of this portrait resembles the work of the photographer David Wilkie Wynfield. He was known for his "fancy portraits" of artist friends dressed in costume as characters from English history. These pictures fall somewhere between portraiture and genre and were made with the lens placed slightly out of focus in order to suggest the softer outlines of a painting. Cameron received some instruction from Wynfield, and their work was compared in the photographic and fine art press in 1864 and 1865. In a letter written to William Michael Rossetti on January 23, 1866, Cameron acknowledged Wynfield's influence: "To my feeling about his beautiful Photography I owed *all* my attempts and indeed consequently all my success."

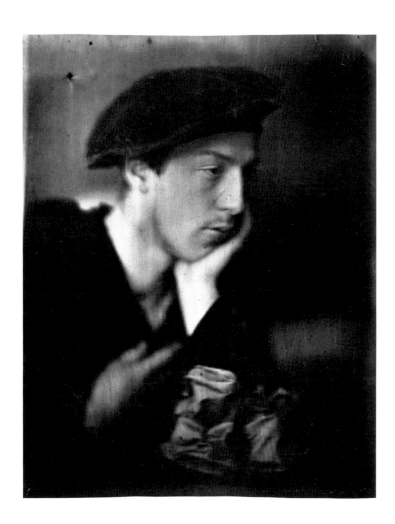

PLATE 5

Paul and Virginia ·

1864

Albumen print
25.4 × 19.9 cm
84.XZ.186.3

The title of this picture is taken from Jacques-Henri Bernardin de Saint-Pierre's romance *Paul et Virginie* (1787), which appealed to a wide Victorian readership and went through several English editions. Cameron may have read the novel in its original French as a child. The story is a moral fable centered on the virtues of true love and chastity, in which the protagonists are children. The narrative is structured upon a dramatic shipwreck on the coast of the French colony of Mauritius, in which Virginia dies because of her modesty, refusing to shed her clothes so that she can be rescued.

Cameron re-created the tropical setting indoors with a mise-en-scène that includes an oriental-style parasol and a scattering of greenery on the floor in the foreground. The children—Freddy Gould (at left; the son of a local fisherman) and Elizabeth Keown (at right; the daughter of a fortkeeper on the Isle of Wight)—perform their roles while draped in pastoral robes. Their behavior toward each other is exemplary—they do not tussle over the parasol but gladly share it. Cameron placed the camera in a low position and organized the composition so as to show the models full length, a pictorial device commonly seen in the child studies of Lewis Carroll. The boy appears to be teetering backward, no doubt due to the length of time and endless instructions required in the preparation for exposure. Cameron was evidently troubled by the undue prominence of his feet and attempted to downplay their presence by taking the rather unusual step of retouching this area of the negative.

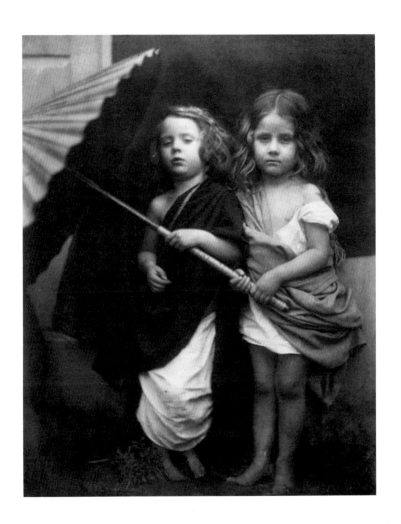

PLATE 6

The Infant Bridal

1864

Albumen print
23.3 × 19.5 cm
84.XZ.186.24

In *The History of Our Lord as Exemplified in Works of Art* (1864), the art historian and Christian iconographer Anna Jameson advised her Victorian readership that "we need sometimes to be reminded of the sacredness of childhood." The idea of children as innocent lovers and icons of cherubic contentment was explored by Cameron in several studies made within the first few years of her career in photography.

In *The Infant Bridal* the models are again Freddy Gould and Elizabeth Keown (see pl. 5). The title of the picture is taken from a poem of the same name by Aubrey de Vere, first published in 1855. A romantic idyll in three parts, it describes the betrothal of two infants, which secures peace between two warring kingdoms. This narrative provided Cameron the excuse to photograph the children in a semiclothed state, ordinarily a violation of Victorian convention.

Cameron was at her most directorial in situations that required the orchestration of a narrative involving child models. In this picture the two subjects are huddled together on a studio chair, joined in a holy union. The cloth that drapes their lower anatomies binds them together at the chest, as though they are Siamese twins. The curve of the chair serves as a halo element, further adding to the aura of sacredness that surrounds them.

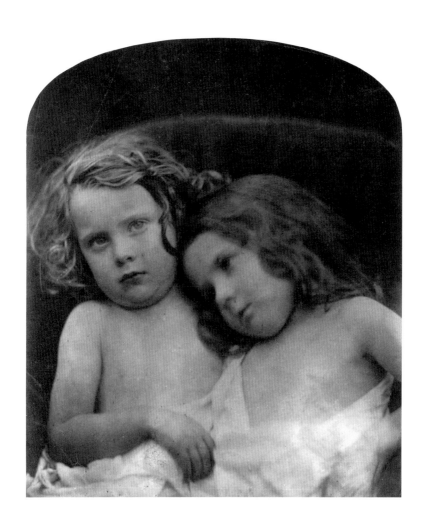

PLATE 7

Faith

1864

Albumen print
23.8 × 18.5 cm
84.XZ.186.31

This study was conceived as part of a series of nine photographs whose title, Fruits of the Spirit, is derived from Galatians 5:22–23: "But the fruit of the Spirit is love, joy, peace, long-suffering, gentleness, goodness, faith, meekness, temperance: against such there is no law." The series was Cameron's first sustained attempt to address religious subject matter; she exhibited it in Scotland in 1864 and presented the group to the British Museum in January 1865. Later that year the series was also included in the Dublin International Exhibition.

Cameron's approach to the problem of illustrating the nine fruits of the Spirit was to establish a pictorial formula and employ as models Mary Hillier, a maid in her household, and Elizabeth Keown and her sister Kate. The pictures are posited between the spirituality and idealism of the Virgin Mary and the everyday existence of the working woman, Mary Hillier. The images blur the lines between the heavenly and earthly, sexual and nonsexual, and in the case of the children, male and female.

At the lower-right corner of *Faith* there is the somewhat awkward intrusion of Hillier's coarsened hand, which unintentionally serves as a reminder of the mundane reality of harsh physical labor and the proximity of it to Cameron's photographs.

The sisters appear to be dutifully obeying Cameron's instructions and convey a strong presence as they perform for the camera. The child at right (Kate) has her hands clasped in prayer, masquerading as the infant Jesus, while the other (Elizabeth) clutches a wooden cross after the biblical type of John the Baptist. Both girls are draped in decidedly spare garments, calculated to emphasize their naturalness. They represent an iconographic model that is discussed in the writings of Anna Jameson: "Such representations of the two holy children, sublime in their innocence—the one predestined to die for mankind, the other to prepare the way before Him—have, as church pictures, an inexpressible beauty and significance."

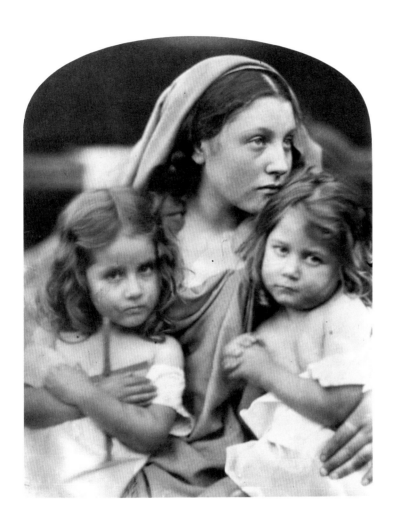

PLATE 8

Mary Madonna

1864

Albumen print
26.7 × 20.8 cm
84.XZ.186.76

The striking and unusual effect that Cameron achieved in many of her portraits is due in large part to the closeness of the camera to the subject. In *Mary Madonna,* inscribed "actual size Life," Mary Hillier's head fills the entire composition. In a letter to Sir John Herschel (pl. 25) in December 1864 Cameron clearly stated her unorthodox approach: "I believe in other than mere conventional topographic photography— map making and skeleton rendering of feature and form without that roundness and fullness of face and feature, that modelling of flesh and limb, which the focus I use only can give."

Cameron perceived photography as a graphic medium of expression to be directed primarily at artists and cared little for the photographic conventions of the time. Throughout her career she submitted prints for sale or exhibition even if the negative was cracked or fingerprinted. In December 1874 she remarked in a letter to Sir Edward Ryan: "As to spots they must I think remain. I could have them touched out but . . . artists

for this reason amongst others value my photographs." While applauding the expressiveness and vigor of Cameron's portraits, the photographic press remarked bitterly on the implications of her technique. Her work was considered "unfeminine" and antithetical to the seamlessly executed prints of other Victorian photographers. Her outlook was shared, however, by the nonphotographic press. In June 1864 a reviewer for the *Athenaeum* described her work as "dreadfully opposed to photographic conventionalities and proprieties. They are the more valuable for being so."

In Hillier, Cameron possessed a model who expressed the qualities that were considered the essence of womanhood. She posed so often in the role of the Virgin that neighbors in Freshwater began to call her "Mary Madonna." In her *Annals* Cameron described Hillier as "one of the most beautiful and constant of my models, and in every manner of form has her face been reproduced, yet never has it been felt that the grace of the fashion of it has perished."

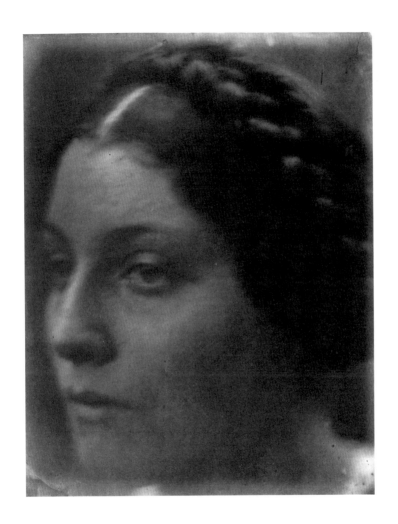

PLATE 9

PLATE 10

The Five Wise Virgins
1864

The Five Foolish Virgins
1864

Albumen print
25.4 × 20 cm
84.XZ.186.40

Albumen print
24.8 × 19.9 cm
84.XZ.186.41

According to Matthew 25:1–4: "Then shall the kingdom of heaven be likened unto ten virgins, which took their lamps, and went forth to meet the bridegroom. And five of them were wise, and five were foolish. They that were foolish took their lamps, and took no oil with them: but the wise took oil in their vessels with their lamps." In illustrating the parable of the wise and foolish virgins, Cameron selected a theological narrative that is comparable in dogma to the Last Judgment. In its broader message, the wise (or righteous) virgins were those who led virtuous lives and were therefore prepared to enter heaven. The foolish virgins were those unrighteous women who were unprepared for the coming of the bridegroom (Christ) and consequently had the gates of heaven closed to them.

Cameron took great pains to illustrate the lesson according to traditional iconography. The wise virgins, huddled together in a phalanx of figures, are modestly veiled, solemn and severe, and bear oil lamps, upright and (supposedly) flaming. The foolish virgins reveal long tresses of unbound hair, suggesting their moral corruption. Their expressions are remorseful and penitent. These women are arranged within the identifiable architectural space of the studio, complete with skylight and black drape. Mary Hillier is recognizable in both studies; the names of the other subjects are unknown.

This pairing was registered for copyright in December 1864 and exhibited at the Dublin International Exhibition of 1865. It was not well received by the critic of the *Photographic Journal*, who remarked: "It is difficult to distinguish which are the 'Wise' and which are the 'Foolish,' the same models being employed for, and looking equally foolish in, both pictures. . . . we should be doing an injustice to photography to let them pass as examples of good art or perfect photography."

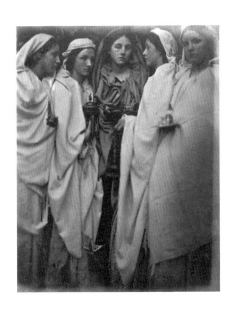

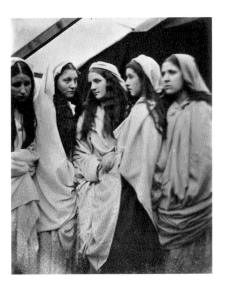

PLATE II

The Salutation

1864

Albumen print
21.6 × 17.8 cm
84.XZ.186.59

The emotional and physical bonds between women form the basis of many of Cameron's greatest images. She possessed an uncanny ability to harness the subtleties of body posture and gesture to serve a given narrative end. It is when picturing groups of two or three figures that her directorial skills can best be seen, especially in those instances where the camera is applied to a religious theme.

Cameron's composition for *The Salutation* illustrates a scene from the life of the Virgin. Often referred to as the Visitation, the event is described in Luke 1:41–42: "And it came to pass, that, when Elizabeth heard the salutation of Mary, the babe leaped in her womb; and Elizabeth was filled with the Holy Ghost: and she spake out with a loud voice, and said, Blessed art thou among women, and blessed is the fruit of thy womb."

The import of this scene is captured in Cameron's study, which reveals the intimacy between Mary and her cousin, the mother-to-be of John the Baptist. The foreground, profile figure of Mary Hillier, swathed in drapery, gives the greeting. Her lips softly trace the forehead of the unidentified model in a dark robe, who plays the role of Elizabeth; her protective hand rests on the other's arm. This picture anticipates *The Kiss of Peace* (1869), which Cameron considered her greatest work (see p. 142).

The pictorial drama in *The Salutation* is akin to that found in a Giotto composition; in fact, Cameron commonly titled variations of this subject as "after the manner of Giotto." The influence of the Florentine artist's imagery is not surprising, since for many years Cameron was a member of the Arundel Society, an organization founded in 1848 by Prince Albert, John Ruskin, and others that was dedicated to the reproduction of paintings by Giotto and other artists for the education and improvement of public taste in art.

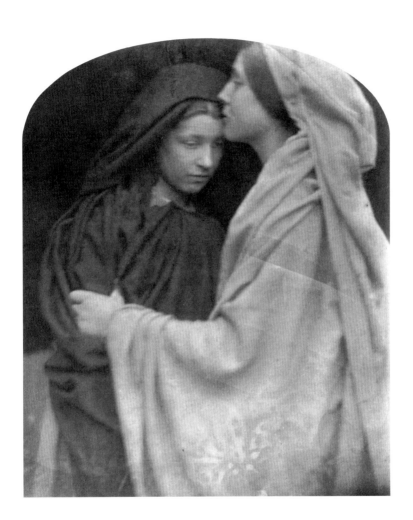

PLATE 12

G. F. Watts

1864

Albumen print
21.8 × 19.5 cm
84.XZ.186.55

George Frederick Watts was born in London in 1817. In 1835 he entered the Royal Academy Schools and spent many hours studying the Elgin Marbles in the British Museum. From 1843 to 1847 he studied painting in Florence while staying at the home of Lord Holland, the British minister to the court of Tuscany. When he returned to England, he was taken in as the permanent houseguest of Cameron's sister Sara Prinsep at Little Holland House, a rambling property obtained through the graces of Lord Holland.

From his studio at Little Holland House, Watts tirelessly corresponded with Cameron on matters of art. His vision of creating a Victorian pantheon that could transcend the age was one he shared with her. He referred to his contemporary series of portraits as "The Hall of Fame" and in 1861 bequeathed over sixty works to the nation, depositing them in the newly opened National Portrait Gallery in London. The breadth and grandiosity of his vision was not lost on Cameron, who followed this approach with her didactic, bust-length portraits.

Watts was sometimes moody and introspective in character, but Cameron was nonetheless very fond of him. This seated profile portrait reveals the combination of intimacy and admiration that marked their friendship. The carefully crumpled drapery in his sleeve is not an arbitrary feature of the picture, but rather an attempt on Cameron's part to demonstrate that photography could achieve such painterly effects.

The presentation album Cameron gave to Watts in 1864 is dedicated with the following inscription: "To the Signor whose generosity I owe the choicest fruits of his Immortal genius I offer these my very first successes in my mortal yet *divine!* art of photography."

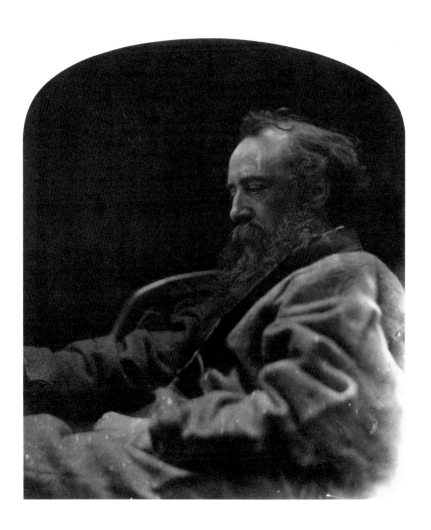

PLATE 13

Professor Jowett

1864

Albumen print
26.5 × 21.6 cm
84.XZ.186.71

Professor Benjamin Jowett of Oxford University was a close friend of Tennyson's and often visited him at Freshwater. In 1862 he wrote to Tennyson's wife, Emily, "I sometimes think that merely being in the neighbourhood of Alfred keeps me up to a higher standard of what ought to be in writing and thinking." Jowett's annual visits to Farringford became a tradition in the Tennyson household, and he often took up lodging nearby for prolonged spells of study. It was during these sojourns that he came to know Cameron, who was a perpetual presence at her neighbors' home. Jowett's description of Cameron is as accurate a picture of her as her portrait is of him: "She has a tendency to make the house shake the moment she enters, but in this dull world that is a very excusable fault."

Jowett made his early reputation by Latin scholarship, but his real love was Greek literature. In 1855 he was appointed Regius Professor of Greek by the Prime Minister, Lord Palmerston. He translated many of the great works of ancient Greece into English, including the *Dialogues* of Plato, and listed writings by Aristophanes, Sophocles, and Thucydides as being among his favorites. He was famous for his public readings of the classics and his erudite college lectures. According to his biographer, Jowett's public speaking voice was remarkable for the "richness in its tones, as of a silver bell, which charmed the ear." Although his name is now obscure, Jowett was the most renowned Oxford master of the nineteenth century.

Cameron's powerful portrait seems to capture the very essence of Jowett's formidable personality, honed as it was on intellectual and literary pursuits. He is pictured as a beacon of knowledge, shining forth against the dark backdrop, attired in a dress coat of fine broadcloth, his waistcoat disclosing a faultless shirt front and white tie. He is holding in his left hand a bound volume that, foreshortened by the short focal length of Cameron's lens, assumes a lecturnlike form that fittingly represents both the man and his work.

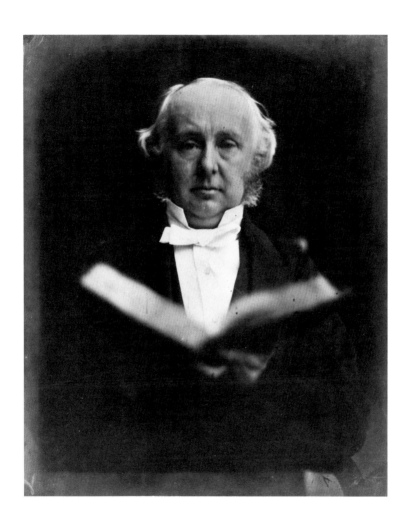

PLATE 14

William Holman Hunt

1864

Albumen print
25.4 × 17.8 cm
84.XZ.186.72

Cameron was described by many of her friends and contemporaries as a lionizer, always searching for important artists and writers to place before her camera. She had intimate access to many of the most influential people in Victorian society and relished the opportunity of photographing them. Cameron also enjoyed the challenge of the confrontation—securing a likeness and demonstrating her ability to draw out the emotional and psychological characteristics of her sitters.

By the spring of 1864 Cameron was sufficiently intrepid to begin transporting her camera equipment from the Isle of Wight to London. It was at Little Holland House that she first met William Holman Hunt, a founding member of the Pre-Raphaelite Brotherhood and one of the leading painters of the day. Hunt's works, much admired by the Victorian public, were widely reproduced as engravings and published in art magazines. He was drawn

to the exoticism of the Middle East and traveled there widely in the 1850s and 1860s. In June 1854 in Jerusalem he began *The Finding of the Saviour in the Temple,* which secured his reputation as the religious painter of his age.

When Cameron photographed Hunt, she presented him as the painter of the Holy Land, in an informal studio setting with a dark curtain serving as a backdrop. He sports an elegant headdress and striped robe with a stylish waistband. This portrait, which is inscribed "Lawn at Hendon," is one of at least two negatives from a sitting that took place at the home of Cameron's invalid sister, Maria ("Mia") Jackson. In a letter to a friend written in June 1864, Hunt commented rather indifferently: "I can't say I took interest enough in my own face to look at the portrait very closely, but my impression certainly was that it made my face less ugly than I was accustomed to see it in the glass."

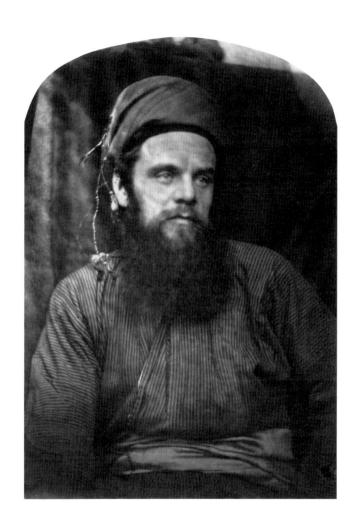

PLATE 15

Minnie Thackeray

1865

Albumen print
27.3 × 23.5 cm
84.XZ.186.100

The Cameron household was continually alive with new and interesting visitors, most especially young women. Two important guests early in 1864 were Anne and Harriet Marian ("Minnie") Thackeray. Their father, the author William Makepeace Thackeray, had died suddenly on Christmas Eve 1863; Cameron promptly invited the two bereaved daughters to visit Freshwater for a holiday. She made available to them the guest quarters at Dimbola, which afforded them immediate access to the Tennyson family, good friends of their father's.

Cameron introduced the Thackerays to the whirl of Freshwater's extensive social life, and they soon became caught up in the atmosphere, returning to spend Easter there in 1864. At this time Anne described Freshwater as "the funniest place in the world. . . . Everybody is either a genius, or a poet, or a painter or peculiar in some

way." Cameron was fond of both sisters and photographed them at different times in the months following their father's death. In a gesture of friendship, she presented an album of sixty-one photographs (now in the Gernsheim Collection at the University of Texas at Austin) to Anne in 1866.

This 1865 portrait of Minnie presents her in a chair against a simple studio backdrop of diaphanous cloth. Cameron used the fabric to filter the sunlight that entered her "glass house," a converted henhouse. The pose is more attuned to conventional studio portraiture than one ordinarily finds in Cameron's photographs, but the composition is otherwise stripped down to a bare minimum. Minnie, still in mourning, wears a dark dress and black hat. Cameron's gaze is not so much on the femininity of her subject as on the grace of her posture and her wistful, melancholic expression.

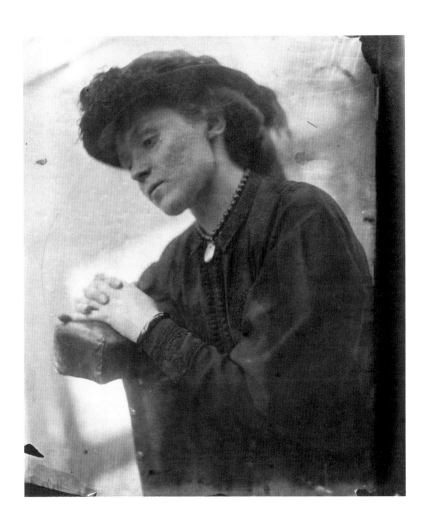

PLATE 16

The Infant Samuel

April 1865

Albumen print
24.7 × 20 cm
84.XZ.186.74

In *The History of Our Lord as Exemplified in Works of Art,* Anna Jameson describes the Old Testament character of Samuel as a subject "capable of much beauty, but [it] has hardly found its way into the category of Art proper." She further remarks that "the pious obedience which marked the life of Samuel is beautifully indicated in the action of the child." In *The Infant Samuel* Cameron employs Freddy Gould, who also appears in other of her compositions (see pls. 5–6), as the child prophet. He amply performs the role required of him, clasping his hands in prayer and glancing heavenward. The composition, spare and uncluttered, has been carefully arranged by Cameron. The boy is seated, legs crossed, at one end of a couch in her studio and is turned in a three-quarter profile toward the camera.

He is seminude, with merely a rumpled cloth to cover his loins. Despite the use of a biblical title for this photograph, there is an underlying seductiveness about the child.

In creating this picture, Cameron demonstrated not only a knowledge of Christian typology but also a desire to transform a humble local boy into a vision of piety and obedience approaching godliness. Another print (in the Gernsheim Collection at the University of Texas at Austin) is inscribed with the words "Speak Lord for thy servant heareth" (1 Samuel 3:9), which underscores the correlation between the story and the image.

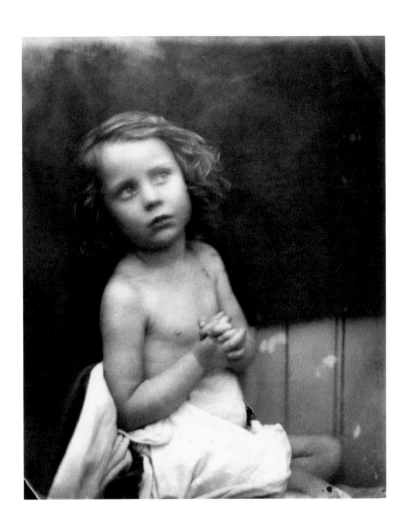

PLATE 17

The Whisper
of the Muse/Portrait
of G. F. Watts

April 1865

Albumen print
26.1 × 21.5 cm
84.XZ.186.96

Each year Watts visited Freshwater for the summer, where Cameron had the opportunity not only to converse with him but also to take his picture. An indefatigable theorist and proselytizer, he was an artistic missionary who sought to improve the condition of mankind through his art. In a letter to Cameron, Watts described his intentions: "If I could carry out my feeling perfectly, my pictures would be solemn and monumental in character, noble and beautiful in form, and rich in colour." Although widely known as a portraitist, his preference was for the creation of grand allegorical compositions. Like Watts, Cameron was preoccupied with reconciling traditional content in art with modern forms of expression.

In *The Whisper of the Muse* Watts is presented as an inspired prophet, although his occupation has been altered to that of a musician. The idea for this photograph may have been inspired by Rembrandt's painting *The Evangelist Matthew Inspired by the Angel* (1661), now in the Louvre, in which the child muse whispers in the saint's ear as he composes his gospel. Cameron made at least two negatives at this sitting, but the variant of this picture (p. 118) does not have quite the dynamism or integration that she achieved here. This study is remarkable for the sophistication of its surface elements, which are skillfully arranged in a tightly compressed space. The sole distracting feature is the expression of Elizabeth Keown (see pls. 5–7), whose head, above Watts's right hand, is daringly truncated (the identity of the other model is unknown). Cameron inscribed the image "a Triumph!"—a proud claim that she had created a work worthy of her great friend and mentor.

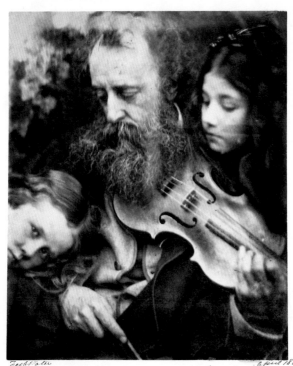

Freshwater April 1865

The Whisper of the Muse

Portrait of G. F. Watts

a Triumph!

PLATE 18

Alfred Tennyson

May 1865

Albumen print
25.6 × 21 cm
84.XZ.186.1

Alfred Tennyson, Cameron's neighbor at Freshwater, was one of the artist's most faithful friends, whom she regarded as a hero and lionized in photographic portraits. By 1850, when she first came to know him, he was a widely admired public figure who had been appointed poet laureate and enjoyed an amiable relationship with the royal family. Cameron took great advantage of her proximity to Tennyson and created many portraits of him over the years. This particular study has become the most well known, since Cameron used it as the frontispiece in the first of her two illustrated editions of his *Idylls of the King*. It also appears in most of her presentation volumes, including the Overstone Album, where it is the very first picture. To augment the commercial value of her Tennyson portraits and to promote her own status as an artist, Cameron often had the poet sign her prints, a task he particularly abhorred.

Tennyson is presented in striking profile as a biblical elder, clutching a tome in his left hand, a fitting metaphor for the strength of his convictions and commitment to action. His bust is draped in a dark cloak, and he appears unkempt, tired, and worn in the face, characteristics of the picture that led him to dub it "The Dirty Monk."

Cameron venerated Tennyson for his ability to express great truths at a time when science and rationalism had undermined many inherited beliefs. This portrait reveals something of his psychological landscape and vulnerability as a human being. Benjamin Jowett (pl. 13) described Tennyson's personality with great accuracy in 1861: "I find he is so greatly mistaken by those who don't know him. . . . No one is more honest, truthful, manly, or a warmer friend. . . . He is the shyest person I ever knew, feeling sympathy and needing it to a degree quite painful."

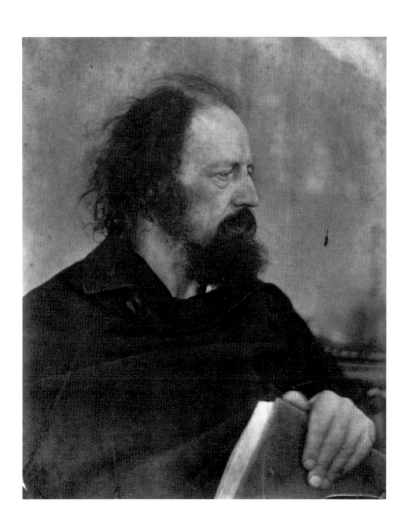

PLATE 19

Prospero

May 1865

Albumen print
26.8 × 21.4 cm
84.XZ.186.32

In the same month that she created her commanding portrait of Tennyson (pl. 18), Cameron photographed the poet Henry Taylor as Prospero, the duke of Milan in Shakespeare's play *The Tempest*. Cameron and Taylor met in 1848 and were neighbors in Kent and later in London. He visited Freshwater for a couple of weeks each spring and autumn; in his *Autobiography* (1885) he described the Cameron household as an environment where "conventionalities had no place." Taylor was an important model for Cameron and a willing accomplice in some of her more extravagant pictorial and narrative explorations with the camera. Sometimes he was photographed as himself; at other times he was presented as Kings Ahasuerus, David, and Lear and as Rembrandt. Together with Tennyson, Taylor is the most frequently cited name in the copyright records for Cameron's photographs at Stationer's Hall, suggesting that she had high prospects for the commercial sale of his image.

Shakespeare's Prospero is a mercurial scholar who learns the secret powers of nature after many years of laborious study. Cameron depicts the character as a sage-like figure with an arresting appearance. Taylor's head entirely fills the frame; Cameron underscores the realism of his portrait in proportion and personality by inscribing the mount of the print with the word "Life." The head is bathed in a shimmering, effervescent light that imparts a liquid quality to the sitter's eyes. The combination of patristic beard and artistic dress cap produces a powerful image of male authority. In the journal *Sun Artists* (1890), Peter Henry Emerson described the picture as "one of her earliest works and one of the best. Recalls Leonardo da Vinci in its elaboration, lighting and sentiment. A great work in many ways."

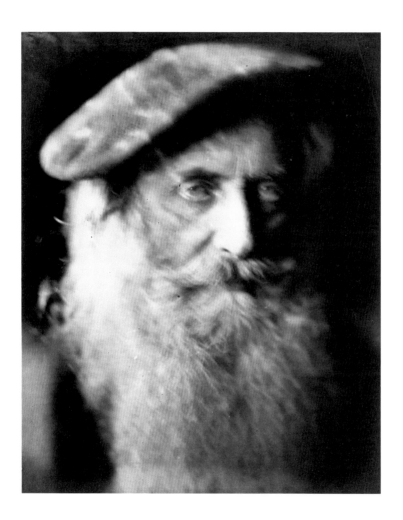

PLATE 20

Lady Elcho/
A Dantesque Vision

May 1865

Albumen print
25.8 × 21.6 cm
84.XZ.186.13

According to Hester Thackeray Fuller (daughter of Anne Thackeray Ritchie), Cameron is said to have remarked that "no woman should ever allow herself to be photographed between the ages of 18 and 90." Cameron seldom permitted others to take her picture once she had reached maturity, and she infrequently photographed older women, thereby tacitly conforming to the notion that feminine representations should subscribe to the conventional requirements of youth and beauty. Conspicuously absent in her body of work are portraits of the talented, mature women who were a powerful presence in the elite society in which she moved.

There are exceptions to this rather narrow rule in instances where Cameron deemed either a subject or a narrative worthy of her camera. Her somewhat unusual full-figure portrait of Lady Elcho (née Anne Frederica Anson) standing under an oak tree in the garden of Little Holland House is inspired by Pre-Raphaelite painting and represents, as the subtitle indicates, "A Dantesque Vision." The subject is attired in a grand brocaded cloak, one that Cameron used with later models. Deciding to photograph outdoors presented the difficulty of working with unmediated natural light, a circumstance with which the artist was unfamiliar. The problem of focus is also evident—the tree is the sole compositional element that is sharply drawn, while the figure and background float in undetermined pictorial space.

At the same sitting Cameron made a seated study entitled *Lady Elcho as a Cumean Sibyl.* Both pictures were on view in Cameron's first exhibition at Colnaghi's in July 1865 and were registered for copyright the same month. Prints of each image were also included in the Overstone Album.

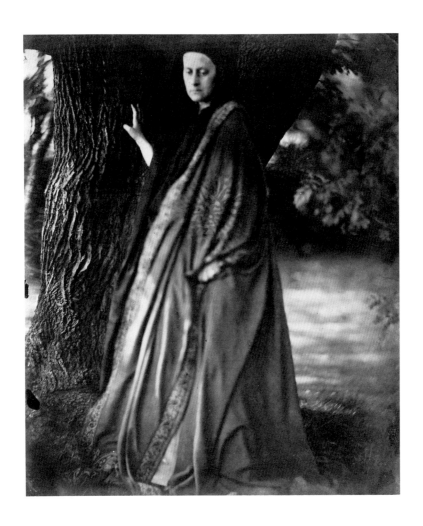

PLATE 21

Lord Overstone

Circa 1865 carbon print
from an 1865 negative
22.4 x 24.2 cm
95.XM.54.3

Lord Overstone was a friend and patron of Cameron's who helped her family financially over a long period and contributed more than six thousand pounds to underwrite the cost of her art. Charles Cameron and Overstone (then Samuel Jones Loyd) were at Eton College together and later became firm friends as members of London's Political Economy Club. Overstone, a wealthy financier, was one of the banking world's most powerful figures; in 1860 he was elevated to the peerage for his contributions in this sphere. He also had a keen interest in the arts and was a prominent collector and philanthropist.

As a token of respect for his encouragement of her art, Cameron presented Overstone with an album of 112 of her pictures on August 5, 1865, which was dedicated with the inscription: "To Lord Overstone from his Friend Julia Margaret Cameron/ Every thing in this book is from the Life & all these Photographs are printed as well as taken by J.M.C." It was the fourth such album she had presented to persons whom she admired and valued for their support and friendship. The considerable personal sacrifice involved in giving such a substantial group of her earliest works to Overstone is typical of Cameron and demonstrates both her great generosity and constant need for validation.

This portrait of Overstone captures the essential qualities of the subject: his shrewd eye and influential presence. The rich values of the carbon printing process complement his darkly clad figure. The stark, black pigment is punctuated by the patches of white in his dress shirt and the languorous shape of his left hand.

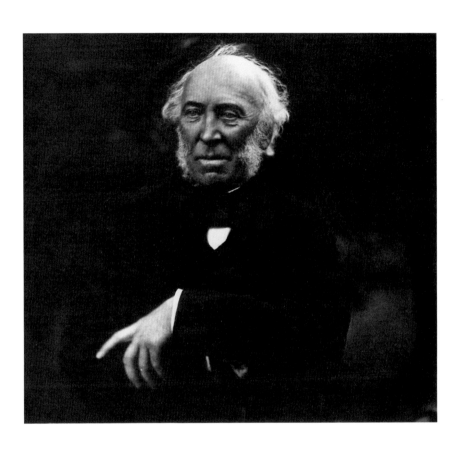

PLATE 22

Young Girl Praying

1866

Albumen print
29.5 × 26 cm
84.XM.443.41

In January 1866 Cameron wrote to William Michael Rossetti and remarked that "for the *first* time in 26 years I am left without a child under my roof—but they are all doing well and struggling to improve and I must not grudge the sacrifice of their sweet society." The absence of her cherished children spurred Cameron on to new endeavors in the art of photography; early in 1866 she moved into a highly creative period with the camera.

Cameron's charming study of a young girl (Florence Anson) at prayer suggests the new direction that her work was to take. She began to move in closer to the subject and to create likenesses that were strikingly individuated. In this portrait, little more than the angelic face and abundant mane of hair of the sitter is in focus. Anson's locks, elegantly pushed over her shoulder, and the flowing blouse contribute opposite tonal values and serve primarily as formal complements to her visage.

With certain negatives Cameron had great difficulties eliminating the bubbles, spots, and similar flaws, and more often than not these imperfections appear in the prints. The deterioration evident in bands throughout the upper, middle, and lower portions of this image is largely the result of toxic framing materials and poor original custodianship. The oxidation and fading around the edges that occurs in many of Cameron's photographs can often be attributed to the vulnerability of the albumen print, the instability of which is accelerated by insufficient washing and toning. For Cameron, aesthetic effect and spiritual feeling were more important than considerations of technical prowess. As her son Henry Herschel Hay commented: "What was looked for by her was to produce an artistic result, no matter by what means. She always acted according to her instinct."

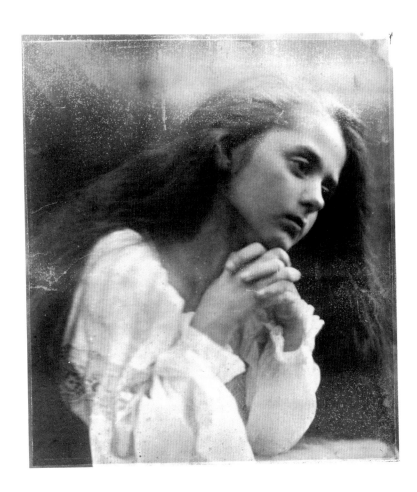

PLATE 23

The Mountain Nymph
Sweet Liberty

1866

Albumen print
36 × 28.1 cm
84.XM.349.11

On February 22, 1866, Cameron wrote enthusiastically to Sir John Herschel: "I have just been engaged in that which Mr. Watts has always been urging me to do, A Series of Life sized heads—they are not only from the Life, but to the Life, and startle the eye with wonder and delight." In the spring Cameron acquired a larger camera, one that used twelve-by-fifteen-inch glass plates and was fitted with a Rapid Rectilinear lens, recently introduced by John Henry Dallmeyer. With this apparatus she began a series of monumental heads.

In *The Mountain Nymph Sweet Liberty* the light is cast evenly across the bust, with the left side of the face thrown into shadow. This creates the illusion of relief and imparts a plastic, sculptural effect. The picture is an inspired visual interpre-tation of Milton's evocation of the moun-tain nymph in his 1631–32 poem *L'Allegro:*

Come, and trip it as you go,
On the light fantastic toe;
And in thy right hand lead with thee
The mountain nymph, sweet Liberty.

Cameron also created at least two other portraits of this model, but they lack the power and directness of this image. While the identity of the sitter is uncertain, she may be the sister of Cyllene Wilson, the strong-jawed subject in *A Bacchante* (pl. 30).

In a letter written on September 25, 1866, Herschel was extravagant in his praise of this picture, describing it as "really a most *astonishing* piece of high relief—She is absolutely *alive* and thrusting out her head from the paper into the air."

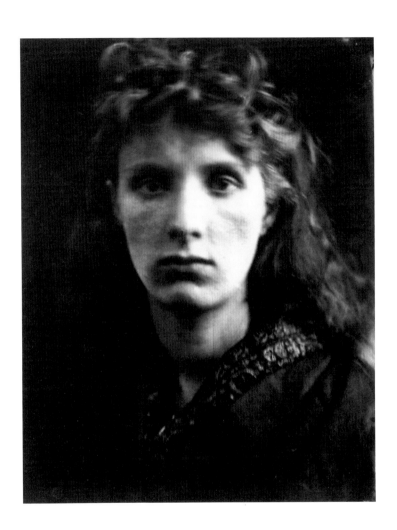

PLATE 24

Beatrice

1866

Albumen print
33.8 × 26.3 cm
84.XM.443.36

In Cameron's greatest portraits of women
the models are drawn from within her fam-
ily circle. She watched many of these indi-
viduals grow from girlhood to adulthood,
and the process of photographing them was
as much about documenting their matura-
tion as transforming their person into
works of an ideal nature. A favorite model
was her niece May Prinsep, who at age
thirteen was one of several orphans adopted
by Sara and Thoby Prinsep. She possessed
a rare, classical beauty; her Italianate looks
were made the subject of many portraits
in the years 1866 to 1874 (see also pl. 39).

The title of this work refers to a
character from Percy Bysshe Shelley's play
The Cenci (1819), which is based on the
true story of a sixteenth-century Roman
family. Beatrice Cenci was the daughter of
Count Francesco Cenci, a tyrant who ter-
rorized his wife and children. In retaliation

for his attempted rape of her, Beatrice plot-
ted with her stepmother and brother to
have him assassinated. The crime was com-
mitted, but the conspirators were caught;
all were executed in September 1599.

Cameron was fascinated by the story
and made a number of different studies of
the central figure of Beatrice. This version
is modeled on a painting, then attributed
to Guido Reni, that was widely engraved in
the eighteenth and nineteenth centuries
and available as a print by Samuel Cousins
at Colnaghi's. The portrait has been impec-
cably stage-managed. As Beatrice, Prinsep
wears a headdress, and her downcast
eyes and wistful expression suggest that
she is quietly resigned to the fate that awaits
her. The lighting is perfect, and the hair
at the left side of the face falls in a scrol-
ling pattern that, together with the left
eye, defines the composition's central axis.

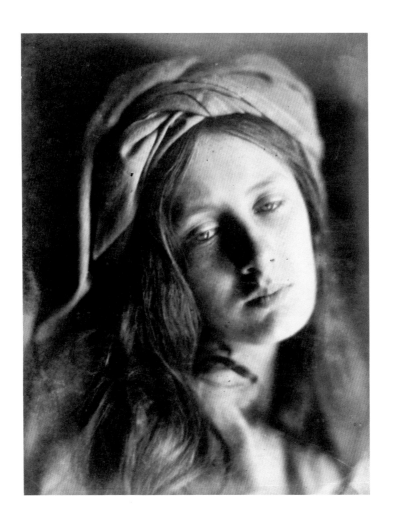

PLATE 25

J. F. W. Herschel

April 1867

Albumen print
35.5 × 27.4 cm
84.XM.349.3

Sir John Frederick William Herschel was the greatest scientist of his generation. He contributed enormously to the early processes of photography by discovering the power of sodium hyposulfite as a fixing agent. Cameron first met him in 1835 in South Africa, where she was recovering from an illness and he was conducting astronomical investigations. They began a close friendship that lasted until his death in 1871.

During the 1840s Herschel corresponded regularly with Cameron, often remarking on the latest discoveries in photography. In November 1864, less than a year after she began making pictures, Cameron presented him with an album of prints "in grateful memory of 27 years of friendship." In her *Annals* Cameron described the depth of her feelings for Herschel: "He was to me as a Teacher and High Priest. From my earliest girlhood I had loved and honoured him, and it was after a friendship of 31 years' duration that the high task of giving his portrait to the nation was allotted to me."

In April 1867 Cameron visited Herschel at Collingwood, his home at Hawkhurst, Kent, and photographed him in a sitting from which at least three negatives were made. Her stated intention was to capture "faithfully the greatness of the inner as well as the features of the outer man." She swathed his shoulders in a drape of dark cloth, concentrating on the monumental form of his head. The gleaming eyes and shock of white hair reflect his creative vision and remarkable intellectual energy.

Cameron was acutely aware of the commercial viability of the Herschel portraits. She promptly registered them for copyright, and in June they went on display at Colnaghi's. The reviewer for the *Athenaeum* described them as "severely and grandly effective pictures of a noble head." This work, one of several Cameron sent to the Universal Exhibition in Paris later that year, created a sensation; she was awarded an honorable mention for "artistic photographs."

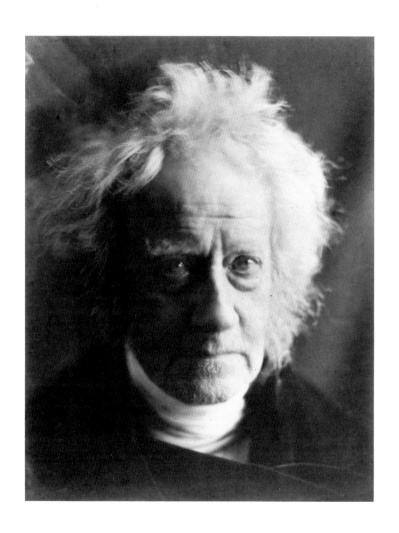

Mrs. Herbert Duckworth

April 1867

Albumen print
34.2 × 26.2 cm
94.XM.12

Mrs. Herbert Duckworth

1867

Albumen print
33.9 × 24.8 cm
84.XM.443.21

Mrs. Herbert Duckworth/ A Beautiful Vision

1872

Albumen print
33.8 × 25.2 cm
84.XM.443.45

Mrs. Herbert Duckworth (née Julia Jackson) was widely regarded as the most attractive of all the daughters born to the Pattle sisters. She was the child of Mia and John Jackson, a physician who practiced for twenty-five years in Calcutta. Her beauty prompted several proposals of marriage, most notably from William Holman Hunt (pl. 14) and the sculptor Thomas Woolner. She was continually sought after as a model by leading artists of the day: Watts drew her often during childhood and painted her portrait in oil in 1874; Edward Burne-Jones used her as the model for the Virgin in his *Annunciation* (1879), one of the great works of Pre-Raphaelite painting. Cameron photographed her most treasured niece and godchild repeatedly over the years, creating a corpus of works that are among the finest examples of her art.

In 1867, at the age of twenty-one, Jackson accepted the marriage proposal of Herbert Duckworth, a barrister. Two striking portraits (pls. 26–27), probably made just prior to her wedding, project an image of heroic womanhood and celebrate her cool, Puritan beauty. The perfect framing of the bust is given great emphasis by Cameron's handling of light, which is carefully cast to accentuate the strength and beauty of the head. This is the most revolutionary aspect of these pictures and is akin to the attention and quality of effort Cameron expended on her images of famous men.

Duckworth was widowed in 1870 and later married Leslie Stephen, the widower of Minnie Thackeray (pl. 15). One of their children was Virginia Woolf, who described her mother in the character of Mrs. Ramsay in *To the Lighthouse* (1927): "The Graces assembling seemed to have joined hands in meadows of asphodel to compose that face." Cameron's 1872 portrait of Duckworth (pl. 28) seems to echo this description with its subtitle, "A Beautiful Vision."

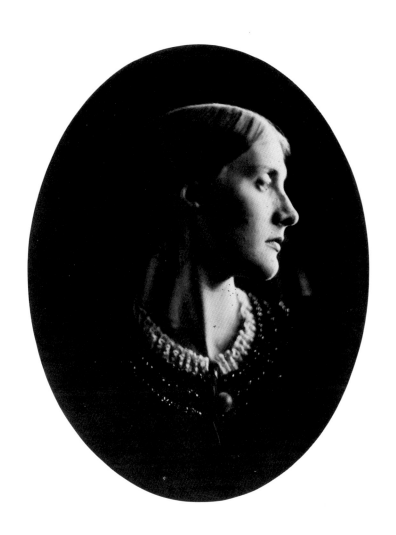

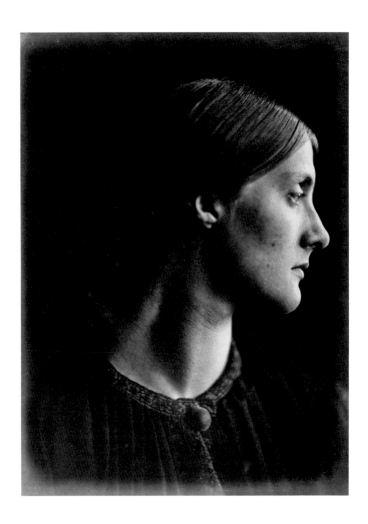

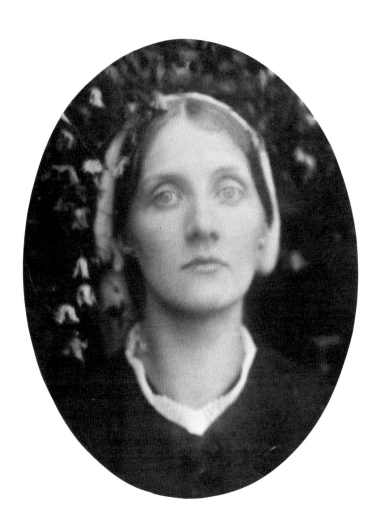

PLATE 29

Thomas Carlyle
1867

Albumen print
36.4 × 25.8 cm
84.XM.443.23

In an 1866 review of Cameron's work published in *Macmillan's Magazine*, Coventry Patmore remarked: "Her position in literary and aristocratic society gives her the pick of the most beautiful and intellectual heads in the world. Other photographers have had to take such subjects as they could get." In the spring of 1867 Cameron landed the opportunity to photograph the historian Thomas Carlyle at Little Holland House. Two negatives were made on the occasion: this frontal monumental head and a profile study.

William Holman Hunt remarked that Carlyle's face, "despite a shade of rickety joylessness, was one of the noblest I had ever seen." Indeed, its sculptural quality prompted Cameron to inscribe some prints with the caption "Carlyle like a rough block of Michelangelo's sculpture." The author of *On Heroes, Hero-Worship, and the Heroic in History* (1841) was, for Cameron, a hero himself, whose convictions regarding the immanence of the deity and a providential order working through natural leaders were entirely in keeping with her own. Carlyle's writings were opinionated and highly intuitive and stirred readers by antagonism rather than sympathy. He posed awkward, provocative questions and told the truth about the condition of society in clear-sighted, often scathing discourses. Yet for all his tremendous critical and analytical powers, Carlyle's weakness was his inability to suggest or supply solutions. Anna Jameson described him with great acuity in her *Commonplace Book of Thoughts, Memories, Fancies* (1854): "He is a man who carries his bright intellect as a light in a dark-lantern; he sees only the subjects on which he chooses to throw that blaze of light; those he sees vividly, but, as it were, exclusively. All other things, though lying near, are dark, because perversely he *will* not throw the light of his mind upon them."

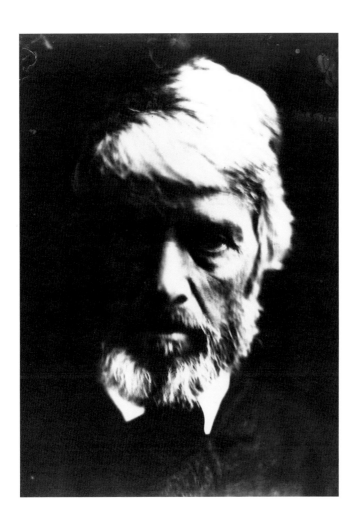

PLATE 30

A Bacchante

June 20, 1867

Albumen print
32.3 × 26.5 cm
84.XM.443.40

Cyllene Wilson, the model for this picture, was orphaned in 1866 and adopted by the Camerons, along with her two siblings (see pl. 23). She posed for several portraits in June 1867, her clearly defined sculptural features being well suited to close-ups. Her look is reminiscent of figures in classical sculpture; in fact, Cameron used her as a model in a suite of relatively unsuccessful renditions of groupings from the Elgin Marbles, which were first put on public display at the British Museum in 1816. Wilson was also the model for *The Vectian Venus* (1872), in which she is presented as the personification of Vectis, the Roman name for the Isle of Wight. As a bacchante she represents one of the followers of Bacchus, appearing during the celebrations held in honor of her master. Her power is also that of the muse, to inspire poets with her enchanting ways.

The mount of this print is inscribed with the words "For the Signor from Julia Margaret Cameron," indicating that it was once owned by Watts. The simplicity of this elegantly modeled bust-length portrait would undoubtedly have appealed to his aesthetic sensibilities. The fine lighting of the head brings the face into highly contoured prominence, leaving the neck and shoulders as bare as marble. Wilson's hair is decorated with three star-shaped brooches, probably an allusion to the frenzied nature of the bacchantes.

In an August 1866 article in the *Intellectual Observer* Cameron was applauded for her ability to use the camera to achieve pictorial results that resembled another art form: "The delineations of the camera are made to correspond with the method of drawing employed by the great Italian artists . . . by selecting good models and calling forth the kind of expression which a judicious artist would desire to enshrine in his work."

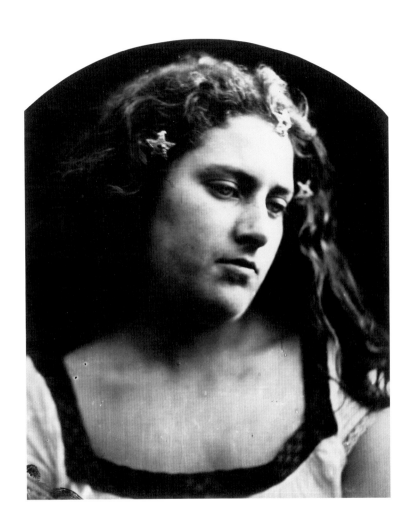

PLATE 31

Henry Taylor

October 10, 1867

Albumen print
34.4 × 26.9 cm
84.XM.443.9

While Cameron's grand monumental portraits attracted much positive attention at exhibitions and in fine art circles, in the photographic press there were still some commentators who criticized the inadequacy of her technique. In the *Photographic Journal* review of the Universal Exhibition in Paris in 1867, Cameron's contributions received a mixed response: "This lady has produced a number of fine studies; but her work is unequal, and in most cases the delineation of her heads is too indefinite. Her process is stated to be the result of an accident. . . . The lens could not do what the lady wanted it to do, and produced an image with a blurred delineation, so she strives for the blurred effect, and in many cases succeeds in turning out a head with a good deal of power in it, and with a softness of outline which is in singular contrast to the ordinary style of photographs."

Cameron went to considerable lengths to declare that her pictures were the work of an artist. This portrait of Taylor is inscribed with the phrase "not enlarged" to make it clear that the work is a study "from life," achieved by direct contact printing from the negative. His immense head, the crown flooded with light, is propped up by his right hand, a practical measure useful during a long exposure. This gesture also reveals the ease and familiarity of his close friendship with Cameron.

A large part of the picture is taken up by Taylor's long, flowing beard, an aspect of his appearance that he described in his *Autobiography:* "There is a feature of my life, conspicuous in these photographs, which dates from this period and the importance of which be it far from me to underrate. This is my beard . . . to be developed into a phenomenon presented by Mrs. Cameron in multiform impersonations."

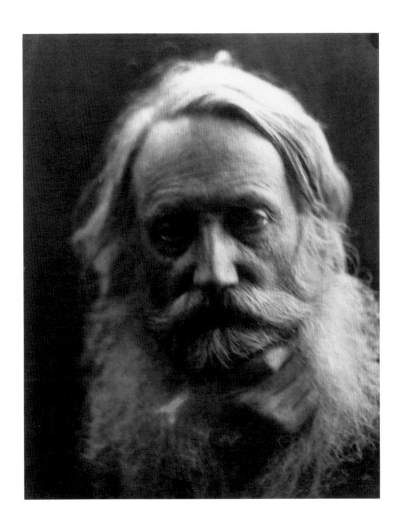

PLATE 32

Rosie

1867–68

Albumen print
33.3 × 24 cm
84.XM.443.63

Children were highly popular subjects for Victorian artists. In 1867 the *British Journal of Photography* published the advice of a Philadelphia photographer on "Taking the Baby." The author asserts that children "try the patience of your Job of an artist" and that the photographer should be ready "to transform them into smiling cherubs on his magic plate." Cameron's approach with her child models varied from insistent directing to delighted appreciation. Her objective was always to transform them into paradigms of angelic contentment.

Cameron's portrait of the unknown Rosie, a child of no more than eleven or twelve, resonates with a luminescent quality. She wears a loose blouse of a romantic style and, bedecked in a beaded necklace, is a figure of iconic beauty. Her hand is placed over her heart in a gesture of youthful piety, and her head is bathed in light from above, similar to the artist's treatment of great men, whose heads seem to be crowned with halos.

Cameron's Freshwater studio was carefully organized to allow a flexible and virtuosic use of light. She used only a narrow stream of top and side illumination and diffused the remainder with white roller blinds. In February 1868 a reviewer for the *Art Journal* remarked on the skillful handling of light in Cameron's portraits on view at the German Gallery, London: "In common photographic portraiture, breadth of light is the rule; but it will be understood how much these examples differ from this rule, when we say, and it is not too much to say of them, that the visitor is occasionally reminded of Caravaggio, Tintoretto, Giorgione, Velazquez, and others of the princes of their art."

Cameron typically employed black drapery and dark materials about her models to create a suitably artistic effect and to ensure that very little light reflected back onto the sitter's face. In this instance the sitter's white garment contributes markedly to the radiance of the composition.

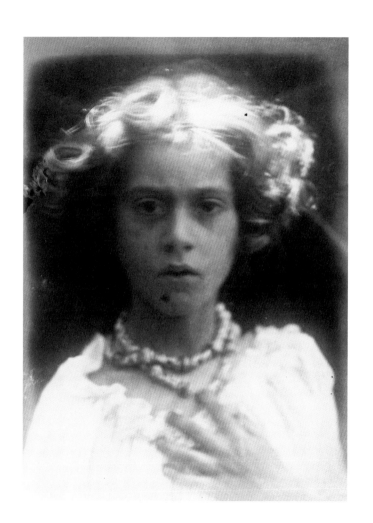

PLATE 33

The Echo

1868

Albumen print
27 × 22.6 cm
84.XM.443.64

The title of this work may refer to the Echo of classical mythology, a nymph of Mount Helicon and attendant of the goddess Hera. According to Ovid's *Metamorphoses,* Echo kept Hera entertained with endless chatter while Zeus dallied with the other nymphs. Catching on to this deception, the angry goddess deprived her of speech as a punishment. Echo could begin no conversation, but only repeat the words of others. While suffering this handicap, Echo became enamored of Narcissus. After he pined away from gazing at his own reflection in a pool, Echo faded away until nothing but her voice remained. She is commonly represented in the visual arts as a ghostly figure grieving over the body of Narcissus.

The model in Cameron's picture is Hattie Campbell, about whom very little is known. Her beauty inspired several portraits by Cameron, all apparently made during 1868. A fine selection of these is now preserved at the Maison Victor Hugo in Paris. The author was an effusive admirer of Cameron's photographs and once remarked: "No one has ever captured the rays of the sun and used them as you have. I throw myself at your feet."

Campbell emerges from the dark background of the picture as an ideal representative of virginal womanhood. The formal sophistication of the portrait is cleverly articulated—the line of her hand is echoed by the hair draped over her shoulder. She wears a medieval-style gown and possesses the features characteristic of Pre-Raphaelite feminine beauty. A print of this image at the Gernsheim Collection at the University of Texas at Austin is appropriately inscribed, "And music born of morning sound/shall pass into her face."

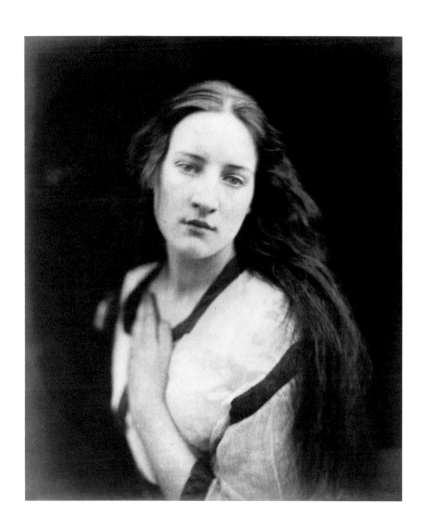

PLATE 34

The Rosebud Garden of Girls

June 1868

Albumen print
29.4 × 26.8 cm
84.XM.443.66

In June 1868 Cameron took the opportunity of photographing the four Fraser-Tytler sisters—Nelly, Christiana, Mary, and Ethel—during their visit to the Tennyson residence, Farringford. The title of the work is taken from a line—"Queen rose of the rosebud garden of girls"—in Tennyson's *Maud* (1855), a poem that he considered one of his finest achievements. In 1855 Dante Gabriel Rossetti sketched Tennyson reading the poem at the home of Robert Browning and described the performance as "delivered with a voice and vehemence which he alone of living men can compass, the softer passages and the songs made the tears course down his cheeks."

Cameron's picture cannot be considered an accurate or direct illustration of the verse. Her group of soporific maidens set against a lush floral background is more of an attempt to capture the quality and feeling of Pre-Raphaelite paintings by Rossetti and Burne-Jones.

Cameron was at her most directorial in this kind of picture, arranging the group according to her whim. This was not entirely to the taste of critics, one of whom remarked in the *Pall Mall Gazette* in January 1868 that "some of the groups or *tableaux vivants* lose, from the very reason of their artificialness, that noble and natural harmony of expression which is the charm of Mrs. Cameron's productions."

The figure seated second from the right, Mary Fraser-Tytler, studied painting with Watts for several years and in 1886 became his second wife, when he was sixty-nine. Mrs. Watts memorialized her husband in a three-volume biography that was published in 1912 under the rather grandiose title *George Frederick Watts: The Annals of an Artist's Life,* a book that offers intimate glimpses of Cameron and her circle.

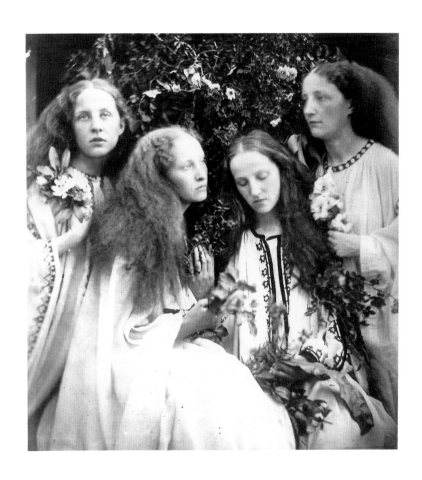

PLATE 35

William Gifford Palgrave

June 1868

Albumen print
34.8 × 26 cm
84.XM.1414.5

William Gifford Palgrave, a diplomat, linguist, and explorer, was a friend of Tennyson's who often visited Freshwater. Educated at Oxford University, Palgrave traveled to India as a young man, where he converted to Roman Catholicism, was trained by the Jesuits in Madras, and became a priest. He later went on to work as a missionary in Syria, where he acquired a taste for Arab life. In 1865 Palgrave published his *Narrative of a Year's Journey through Central and Eastern Arabia (1862–1863)*, which recounts his journey from the Dead Sea to the Persian Gulf. The expedition was paid for by Napoleon III, who instructed him to report on the attitude of the Arab peoples toward France and the possibility of obtaining pure Arabian stallions for breeding in Europe. In making this journey, Palgrave was obliged to travel in disguise, passing as a Syrian Christian doctor and merchant, since the region was off-limits to European travelers at the time. His account describes the topography and geology in some detail and is notable for its charting of small towns and villages in remote desert areas. However, Palgrave's comments on Arab society are notably colonialist in tone. He berates Islam as being responsible for the backward condition of Arabia and describes the Bedouins as false and brutal savages. The work was very popular and was translated into French and published in two editions in 1866 and 1869. After 1870 Palgrave was engaged in diplomatic work for the British government, which took him to Asia Minor, the West Indies, Thailand, and the Philippines. He also published travelogues on Dutch Guyana and Indonesia.

The portrait Cameron made of Palgrave well expresses her interest in adventurer types. Always attracted to colonial-style costume, she photographed him in his cloak and turban, underscoring his reputation as a traveler and explorer.

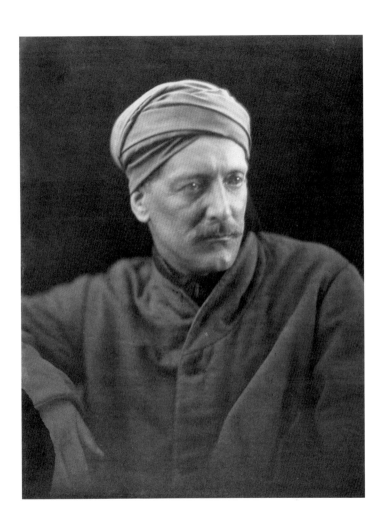

PLATE 36

My Ewen's Bride

1869

Albumen print
31.2 × 24 cm
84.XM.349.8

In Victorian England, marriage was regarded as a cornerstone of society. For Cameron, it was perceived as the ultimate earthly union. In letters to her sons she repeatedly mentioned their marital status and outlined her expectations of them. To her third son, Hardinge Hay, she wrote in 1873, "You should seek all the advantages of social and intellectual life in England and seek the opportunity of being amongst those women . . . whom you might love and might wish to marry."

In November 1869 Cameron's second son, Ewen Wrottesley Hay, married Annie Chinery, the daughter of a prominent doctor on the Isle of Wight. The union was celebrated in a number of prenuptial portraits of the bride-to-be, including a stunning full-length study of her attired in her wedding finery. Annie was Cameron's first daughter-in-law and was eagerly seized upon both maternally and photographically by her new mother-in-law. In Cameron's portraits she is presented in various guises, but always as the progenitor of a new generation of Camerons, descended from the distinguished female Pattle line. Cameron enthusiastically sent prints to friends and relatives and, as if to emphasize divine intercession in family life, inscribed this portrait "God's gift to us."

Soon after their marriage, Ewen and Annie moved to Ceylon to pursue a livelihood on the family-owned coffee plantations. In an 1871 letter to Hardinge, who was also living in Ceylon, Cameron expressed her maternal feelings once more: "Every hour of every day I rejoice in the pure and happy marriage which has secured to Ewen his Treasure and I only yearn and long for the time when you be equally blessed." Ironically, in Ceylon, Cameron's closeness with Annie was brought to an end by the latter's determined resistance to Cameron's endless demands on her son.

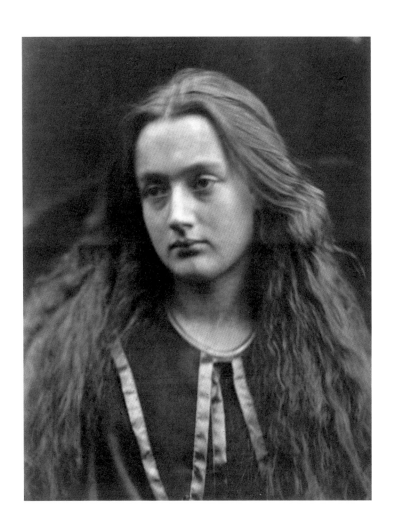

PLATE 37

The Angel
at the Tomb

1869

Albumen print
34.5 × 25.3 cm
84.XM.443.6

This serene study illustrates a key scene in the story of Christ's resurrection: "For the angel of the Lord descended from heaven, and came and rolled back the stone from the door, and sat upon it. His countenance was like lightning, and his raiment white as snow" (Matthew 28:2–3). Cameron chose to employ a female in the traditionally male role of guardian of the Holy Sepulchre. She used her most familiar and trustworthy model, Mary Hillier (pls. 7–11, 40), whose handsome profile and abundant tresses seem in keeping with the drama of Saint Matthew's gospel. A remarkable, otherworldly light floods in from above, causing a halo effect. A print in the collection of the International Museum of Photography at George Eastman House bears an inscription in Cameron's hand: "God's glory smote her on the face/a coruscation of spiritual unearthly light is playing over the head in mystic lightning flash of glory."

As Mike Weaver explains in his book *Whisper of the Muse*, the figure at the tomb also represents the type of Mary Magdalene, whose principal attribute is her hair, with which she concealed her nakedness as a fallen woman and in her humility used to dry the feet of Christ. The picture therefore combines the pure and impure, the sacred and profane. Cameron's use of Hillier—"Mary Madonna"—as Mary Magdalene reinforces this dichotomous theme.

A review of Cameron's photographs in the *Intellectual Observer* of February 1867 drew attention to her skillful rendering of hair: "Beautiful hair, left free, is one of the most poetic of nature's productions, and very subtle and sympathetic are the combinations of light and shade which it exhibits, and which defy the efforts of ordinary artists to reproduce."

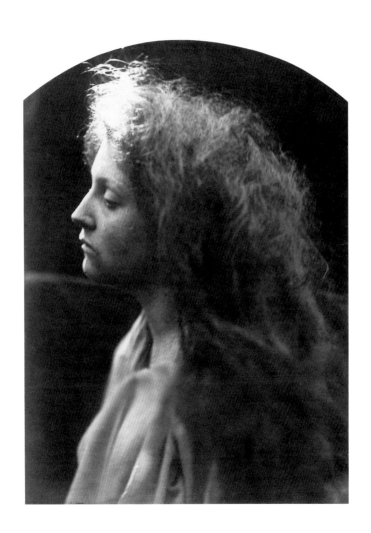

PLATE 38

Marie Spartali

1870

Albumen print
36.2 × 26.6 cm
84.XM.349.2

Greek in heritage and British by birth, Marie Spartali was the daughter of the Greek consul general in London. A sought-after model for her beauty, she posed for Rossetti, Burne-Jones, and Ford Madox Brown. Spartali also studied painting with Rossetti and Brown and developed a personal style that combined elements drawn from Renaissance art and contemporary culture. Her work was exhibited with the Society of Female Artists in London and shown at the Dudley Gallery in 1867 and the Royal Academy in 1873. In 1871 she married William Stillman, an American photographer and early follower of John Ruskin.

Cameron evidently admired Spartali's looks, since she photographed her on numerous occasions in the years 1867 to 1870. Several studies of her, attired in period costume and assuming a historical identity, were registered for copyright in September 1868 and October 1870. Spartali was a public personality and a woman of independent standing, so her portrait was commercially viable.

In this work Cameron models Spartali's bust with a minimum of lighting, an unusual approach for the artist. This produces a virtuosic effect and a heightened relief akin to the sculpted head of a Roman goddess or matron. The camera is positioned slightly below the subject, which imparts an added strength and power to her visage. Rossetti wrote of Spartali in August 1869: "I find her head the most difficult I ever drew. It depends not nearly so much on real form as on a subtle charm of life which one cannot re-create. I think it would be hardly possible to make a completely successful picture of her." This remark provides some measure of Cameron's achievement with this portrait.

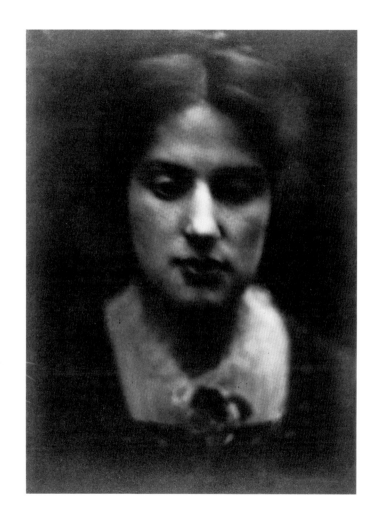

PLATE 39

May Prinsep

October 1870

Albumen print
35.4 × 28.1 cm
84.XP.259.28

In the late summer and fall of 1870 Cameron made several stately three-quarter-length portraits of her niece May Prinsep. In this series Cameron's imagery is closer to Pre-Raphaelite iconography than in any of her earlier work. Some of the portraits were titled simply *A Pre-Raphaelite Study*, as if to underscore Cameron's consciousness of her experimentation in this idiom. She registered a large group for copyright in October 1870 and evidently hoped they would be a commercial success.

The pose adopted by the model is very similar to William Holman Hunt's *Isabella and the Pot of Basil* (1866–68), a painting that gained great popularity in the period through an engraving by Auguste-Thomas-Marie Blanchard. The print, which was published by Gambart in May 1869, enjoyed wide circulation and was much admired by the editor of the *Art Journal*, who described it as "thoroughly imbued with all the best principles of art."

Prinsep stands in a space that has been prepared by casually draping furniture with cloth. Her head is dramatically tilted, allowing her hair to cascade to below her waist. She wears exotic jewelry and an elegant, voluminous dress tied with a cord sash. The mount of this print is inscribed "For Val," indicating that it was intended for the model's brother, Valentine Prinsep, who studied with Watts and later became a distinguished painter himself.

PLATE 40

The Communion

1870

Albumen print
32.7 × 27.2 cm
84.XM.443.65

Many of Cameron's portraits of women and group studies incorporating women and children include flowers or have the figures framed against floral backgrounds in order to enhance the narrative thrust of the representation. In a letter to Tennyson written in 1855, Cameron described a magnolia tree in the garden of her home in East Sheen, London, and its capacity to "send forth a scent that made the soul faint with a sense of the luxury of the world of flowers. I always think that flowers tell as much of the bounty of God's love as the Firmament shows of His handiwork."

In the case of *The Communion*, an elegant spray of full-bloomed lily of the valley is boldly employed as a graphic element in the composition, skillfully framing the interaction of the figures. The inclusion of this blossom, which signifies purity and meekness, suggests that the scene represents the Annunciation. The unidentified youth plays the part of the angel Gabriel, who, bearing a lily, informs the Virgin (Mary Hillier) that she will bear a child. A similar floral motif frames the figures in *Study-Madonna* (Royal Photographic Society, Bath). Here Mary nurses the youthful John the Baptist, who is draped in an animal skin and holds a cross, his traditional attributes. According to Mike Weaver's *Whisper of the Muse,* John also acts as the angel of the Annunciation, with the flowers signifying that Christ is not yet born.

PLATE 41

**Florence/Study of
St. John the Baptist**
1872

Albumen print
34.7 × 25.3 cm
84.XM.443.67

The model for this study of John the Baptist is Florence Fisher, Cameron's great-niece. She was the eldest child of Mrs. Herbert Fisher, one of Mia Jackson's daughters.

The subject is partially clothed in a fringed blanket that doubles as the animal skin garment typically worn by the saint. Her expression is not altogether in keeping with the role that she has been called upon to perform; she does not seem to have been compliant with Cameron's wishes. She is posed against a leafy background, which is sharply differentiated from her figure by virtue of Cameron's close focus. The creeping vegetation, which is so often seen in the Pre-Raphaelite paintings of John Everett Millais and Rossetti, is broadly suggestive of the dialogue between nature and humanity. It is designed to complement the "natural-ness" of Florence performing the role of John the Baptist, even though she is a girl. The right arm across the chest is a gesture of self-protection, but one that also imparts an innocence and humility that Cameron tried to convey in her images of children.

Cameron also photographed Florence in a separate head and torso study in a style that echoes the portraits of Titian and Giorgione. She described it in the title of the work as "after the Manner of the Old Masters." George Duckworth, the eldest son of Julia Duckworth (pls. 26–28), was called upon as well in 1872 to pose as John the Baptist, a choice that was in keeping with Cameron's philosophy of using children as flexible components in her quest to create "high art."

PLATE 42

Angel of the Nativity

1872

Albumen print
32.7 × 24.3 cm
84.XM.443.3

Cameron moved easily in her art between the sacred and the profane, from heavenly to earthly love. In some of her pictures of children the poses recall religious subjects; in others the narratives are structured around classical myths, with a child serving as Cupid and an adult model, usually Mary Hillier, acting as Venus.

In 1872 Cameron made a series of pictures of her great-nieces Laura and Rachel Gurney (granddaughters of Sara Prinsep) dressed as angels. In the 1920s Laura recalled the experience of being photographed by Cameron: "We, Rachel and I, were pressed into the service of the camera. Our *roles* were no less than those of two of the angels of the Nativity, and to sustain them we were scantily clad, and each had a pair of heavy swan's wings fastened to her narrow shoulders, while Aunt Julia, with ungentle hand, tousled our hair to get rid of its prim nursery look. No wonder those old photographs of us, leaning over imaginary ramparts of heaven, look anxious and wistful. This is how we felt, for we never knew what Aunt Julia was going to do next, nor did any one else."

The dramatic affectation and sometimes absurd character of Cameron's art was not lost on George Bernard Shaw, who wrote in 1889: "There are photographs of children with no clothes on, or else the underclothes by way of propriety, with palpably paper wings, most inartistically grouped and artlessly labelled as angels, saints or fairies. No-one would imagine that the artist who produced the marvellous Carlyle would have produced such childish trivialities." Despite its questionable taste, *Angel of the Nativity* is a technically accomplished picture, realized in the rich, lustrous tones of the albumen print.

PLATE 43

This Is My House, This My Little Wife

August 1872

Albumen print
35.6 × 28 cm
95.XM.54.4

The title of this picture is taken from Tennyson's poem *Enoch Arden* (1864), which sold over forty thousand copies within a short time of its publication and became his most popular work. The narrative is based on the dramatic, and supposedly true, story of a fisherman (Enoch Arden) who leaves his family to embark on a voyage and is shipwrecked and stranded for years. In his absence his wife (Annie Lee) marries a local man (Philip Ray) who had been a friend to the sailor in his youth. The fisherman finally returns only to find his wife and children living happily without him. He watches them from a distance and, observing their contentment, decides not to make his presence known.

Cameron chose to illustrate lines taken from an early part of the poem, in which the main characters are not yet adults. This choice of verses was probably calculated to serve the artist's pictorial needs and emphasize the blissful and innocent state of childhood:

A narrow cave ran in beneath the cliff:
In this the children play'd at keeping house.
Enoch was host one day, Philip the next,
While Annie still was mistress; but at times
Enoch would hold possession for a week:
"This is my house and this my little wife."
"Mine too," said Philip, "turn and turn about."

For the girl, who represents Annie, Cameron used the same model as in *Rosie* (pl. 32). The boy playing the part of Enoch is unidentified. Their heads are joined in an expression that conveys unsullied affection. He is dressed in a sailor's uniform; she, in a smart dress—these are genteel children, hardly the type to be scurrying about in a cave. The cat in the girl's lap is also a departure from Tennyson's poem. Cameron intended this print as a gift for her son-in-law, Charles Norman; she inscribed the mount with the caption, "For Charlie Norman who admires my little Enoch."

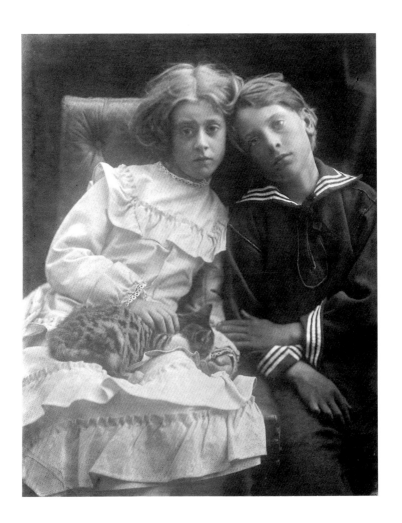

PLATE 44

PLATE 45

PLATE 46

**Charles Norman
with His Daughters
Adeline and Margaret**

July 1874

Albumen print
29.7 × 26.6 cm
94.XM.31.3

**Charles Norman
with His Daughter
Margaret**

July 1874

Albumen print
Diameter: 23.5 cm
94.XM.31.5

**Margaret and
Adeline Norman**

1874

Albumen print
Diameter: 27.5 cm
94.XM.31.2

In 1873 there was a marked downturn in Cameron's production. She made very few new photographs and registered just two images for copyright. She concentrated her energies on exhibitions, which included a large one-woman show in Hanover Square, London, and a representative selection of prints sent to the Universal Exhibition, Vienna. The lull in her activity was almost certainly the result of the death of her daughter, Julia Norman, at age thirty-four. Already a mother of six (like Cameron), Norman went the way of Minnie Thackeray (pl. 15) and countless other women of the period and died in childbirth.

Because her looks were not considered fine enough, Norman was seldom a subject for her mother's camera, a bitter irony in view of the fact that it was her gift of a cam-

era that had been the catalyst for Cameron's remarkable career in photography. Cameron's grief at her death is expressed in a moving series of portraits that she made of the Norman family in the summer of 1874. There is a charged stoicism and solemnity about the grouping of the children around their father (pl. 44), their arms joined in an enveloping gesture. The girls are fulfilling their "natural" role as supportive daughters, consolidating and carrying forward the memory of their deceased mother. Cameron's inscription on this print—"This copy for my beloved Charlie Norman"—adds to the offertory nature of the work. Two other prints in the series (pls. 45–46) were trimmed by Cameron into tondo shapes, further emphasizing the togetherness of the family.

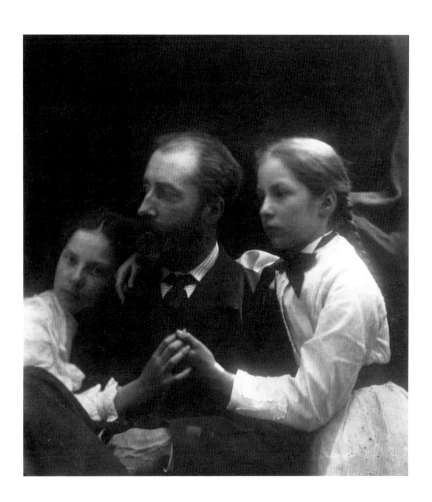

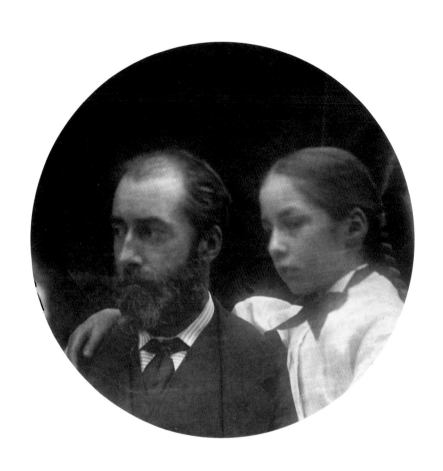

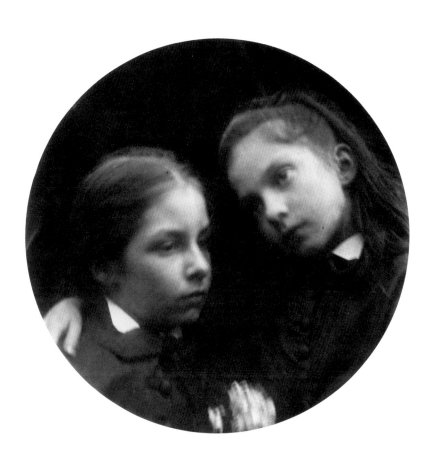

PLATE 47

The Parting of Sir Lancelot and Queen Guinevere
1874

Albumen print
33.8 × 28.1 cm
84.XO.732.1.1.10

Toward the end of August 1874 Tennyson suggested to Cameron that she attempt a photographic illustration of his *Idylls of the King* (1872), a collection of poetry he had written over a period of nearly forty years. Her response was typically enthusiastic: "Now *you* know, Alfred, that *I* know that it is immortality to me to be bound up with you." The enormous production costs and labor involved in such a venture were no deterrent—Tennyson was the finest poet in the land, and Cameron, by association, hoped for both financial gain and further validation of her status as an artist. She was determined to demonstrate that photography was the equal of any other form of book illustration.

Cameron began a search for models who would exactly personify the characters in the *Idylls*. She employed her husband, nieces, friends, and visitors and went to great lengths in order to fit them to the most appropriate narrative. For *The Parting of Sir Lancelot and Queen Guinevere* she purportedly expended forty-two negatives before she achieved the desired result. Her principal difficulty was in finding the right model to perform the role of Sir Lancelot; she eventually found a porter at the local Yarmouth pier whom she considered suitable.

Cameron's picture describes the final embrace of the tragic lovers before they part forever:

And Lancelot ever promised, but remain'd,
And still they met and met. Again she said,
"O Lancelot, if thou love me get thee hence,"
And then they were agreed upon a night
(When the good King should not be there)
* to meet*
And part forever. Passion-pale they met
And greeted; hands in hands, and eye to eye,
Low on the border of her couch they sat
Stammering and staring; it was their last
* hour,*
A madness of farewells.

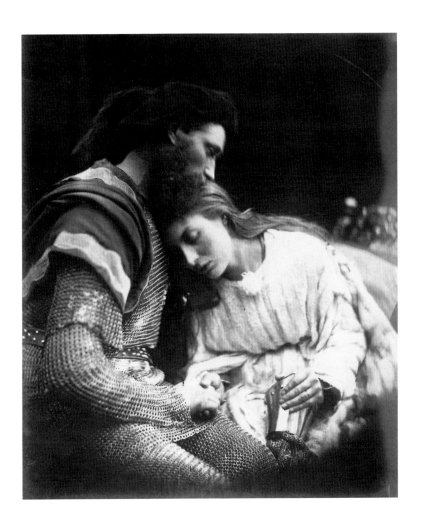

PLATE 48

King Cophetua and
the Beggar Maid

1875

Albumen print
32.1 × 26.5 cm
84.XO.732.1.2.9

Cameron's ambitious project to illustrate Tennyson's *Idylls* resulted in two lavishly bound volumes. The second of these, issued in May 1875, included illustrations to additional poems. Like the first volume, it featured thirteen photographs, one of which was a frontispiece portrait of the poet. The pictures were accompanied by excerpts from Tennyson's verse, painstakingly written in Cameron's own hand and lithographed for multiple reproduction. His signature was often reproduced under the poems and with her portrait of him. This enhanced the value of the books and validated Cameron's claims for the reciprocal status of poetry and photography. In addition to bound volumes, the photographs were also sold individually and made available as albumen and carbon prints. While Tennyson had very little involvement in Cameron's compositions for the *Idylls*, he found her studies to be well attuned to his works. Despite her best efforts, however, the set failed commercially.

Cameron's composition for *King*

Cophetua and the Beggar Maid illustrates with accuracy and élan the story of Tennyson's "The Beggar Maid" (1842). The humble servant, her arms across her breast, passes in front of the king, who steps down to greet her. The emphasis in the poem is on the appreciation of beauty and the power of love to transcend earthly impediments—here the glaring difference in class between the monarch and the maid.

The composition has the atmosphere of a stage set, with carefully arranged lighting that accentuates the interaction of the figures. The low viewpoint emphasizes the constructedness of the image—King Cophetua is captured in the very act of stepping down, and the beggar maid's humility and virtue are apparent in her bare feet and modest gesture. The subjects are enclosed within cloth-covered makeshift walls decked with plush curtains. These props and the bare wooden floor are closely linked in spirit to the amateur theatricals in which the members of the Cameron and Tennyson households customarily took part.

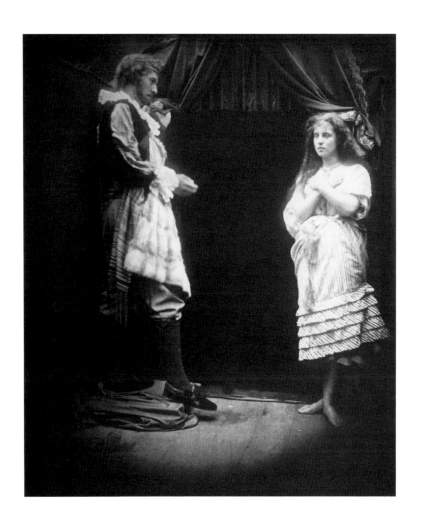

PLATE 49

Cingalese Girl

1875–78

Albumen print
25.3 × 18.9 cm
86.XM.636.2

By the early 1870s the Camerons had fallen on hard times. Deciding that they would be better off living with their sons in Ceylon, where living expenses were far lower, they set sail from Portsmouth in October 1875. Their destination was the fishing village of Kalutara, on the southwest coast of the island. In a letter written in November 1876, Cameron reflected on the benefits of her new environment: "My wonder for instance has been tamed but not my worship—The glorious beauty of the scenery—the primitive simplicity of the Inhabitants & the charms of the climate all make me love and admire Ceylon more and more."

It is not known to what extent Cameron continued to photograph after her move to this new environment. Few images have survived—there are less than thirty examples in existence. Various factors may have affected her creative output—the harsh heat created problems of peeling collodion and glutinous varnishes, and this, together with the lack of readily available fresh water for washing prints, lessened the odds of obtaining good-quality pictures. More importantly, she no longer had an audience or market for her work and therefore could hardly justify the expense of materials.

Cameron's photographs from Ceylon are mostly portraits of maidservants and plantation workers, posed either individually or in intimate groups. Occasionally she photographed members of the same family together; these works more or less imposed the values found in photographs of her own family onto individuals of the different culture. Although Cameron admired her subjects for their beauty and poise, they are clearly represented as "other." In this picture the camera is positioned low and close to the sitter. While intimate in scale, the composition is organized so as to emphasize the ethnicity of the child, whose bare and hardened feet are prominently lighted. The interior setting perhaps suggests that the girl was a domestic servant.

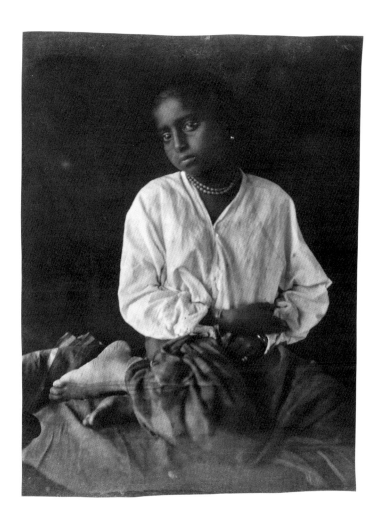

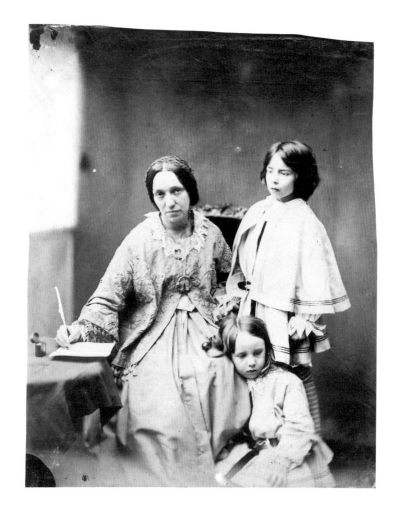

Lewis Carroll. *Julia Margaret Cameron and
Her Children Charles and Henry*, 1859.
Albumen print, 20.1 × 15.7 cm.
Michael and Jane Wilson Collection.

Real and Ideal:
The Photographs of Julia Margaret Cameron

David Featherstone: Let's begin our discussion with *Annie* (pl. 1), which Cameron inscribed, "My very first success in Photography." This inscription is unusual, because here is a photographer who has actually said, "This is my first success." Perhaps we can start with what we know about the circumstances under which she began to photograph. Who were her teachers and her influences? What was it about this picture that made her proclaim it a success?

Julian Cox: In *Annals of My Glass House*, the autobiographical statement Cameron wrote in 1874, she doesn't mention who her teachers and collaborators were. She first learned of photography through Sir John Herschel in the early 1840s; in the 1850s she corresponded with David Wilkie Wynfield and later had some photographic instruction from him. However, she was never explicit about who guided her through the many pitfalls that she must have experienced.

Weston Naef: An album Cameron presented to her sister Maria ("Mia") Jackson, now in the Hochberg-Mattis Collection in New Mexico, provides some clues, since it contains works by photographers other than herself. Oscar Gustave Rejlander is included, and there are several pictures that reveal her earliest artistic connections. It would seem to me that Rejlander, who was a visitor to Freshwater in the 1860s, is the primary person we know was by her side.

Joanne Lukitsh: There were people in Cameron's circle, if not in the immediate nucleus of people in Freshwater, who would have been able to advise her about photography. Lord Somers, her brother-in-law and a fairly prominent amateur photographer, was one of these. Some of the pictures in the Mia Album have been variously attributed to him, others, to a possible collaboration between Cameron and Rejlander.

JC: An important consideration is that Cameron and her family lived on the Isle of Wight, several miles away from the mainland, where she was separated from the diverse influences to be experienced in London.

Judy Dater: Has anyone ever seen photographs that Cameron is known to have done before *Annie?*

JC: According to Cameron's writings, she received a camera on Christmas Eve in 1863 and by early the following year had recorded her first success. It is not known how much work she did in the five-week period prior to creating *Annie*, which she described as her great beginning at the end of January 1864. And, as Joanne suggests, the Mia Album contains photographs that Cameron may have made, with the guidance of Rejlander, before receiving a camera.

JD: The fact that she writes that it's her first success makes me wonder if it's the first picture that actually came out or if it's the first one that arrested her in terms of what she saw in the photograph. I remember the picture that I considered my first success, and I know why I considered it a success.

WN: How many pictures had you made before you arrived at something you called your first success?

JD: Oh, I don't know. Several hundred, I suppose.

WN: So it would have taken a fair amount of experience to create what you considered your first success. I have always wondered how this picture could be Cameron's very first success and how many attempts must have occurred before this. Here is a woman who is very comfortable with words, and she doesn't just say "my first success," she underscores it by saying "my very first success." What did she mean to tell us in that?

Pamela Roberts: All the previous prints of this I've seen are just inscribed "my first success"; this is the first I've seen that says "my very first." It looks like a later print to me. It is also a good-quality print; maybe she went back later and reprinted it.

JC: This picture is from the album that she presented to Lord Overstone in August 1865, so the print may postdate the negative by more than a year, when she evidently had advanced a great deal technically. The inscription is significant within the context of this album as a public proclamation to a supporter of her work. Joanne, I know the Watts Album has a couple of versions of this picture. What kind of inscriptions accompany those prints?

JL: In the Watts Album they are not inscribed. There are two versions that face each other. They are trimmed and toned differently, and the highlights in the hair in the upper-right-hand corner—at the crown of the head—are slightly touched up so they are not quite so bright. A note from Cameron attached to a copy of the print owned by the descendants of the girl—Annie Philpot—includes a statement that is interesting not only for its information but also for how she establishes the idea of achievement. She writes: "My first perfect success in the complete Photograph owing greatly to the docility & sweetness of my best & fairest little sitter. This Photograph was taken by me at 1 p.m. Friday Jan. 29th. Printed—Toned—fixed and framed all by me & given as it is now by 8 p.m. this same day."

DF: That quote underscores Judy's question about what kind of success this was for Cameron. If she became so excited about it that she completed the whole process, and not only framed it but presented it to Annie's father the same day, it suggests that there was some kind of light bulb that went off, that she realized that this is what she was looking for.

JD: So it wasn't just the technical aspect of the picture that excited her; it was also the subject.

WN: I wonder if what we're seeing here is an instance where Cameron is still searching for her own voice; that is, phrasing a picture more in keeping with what she has seen created by others. If this is the case, when she says "my first success" it could point us more toward an interpretation that she is seeing this as a technical success.

JC: Yes, I think the technical aspect is a significant measurement of the success. This picture was supposedly made with her first camera, which used nine-by-eleven-inch glass plates. The print has been trimmed significantly for presentation in the album.

The composition is very carefully aligned. Look at the dark background above the girl's head and how it is on the same trajectory as the lapel of her coat. On the left-hand side we see what seems to be some semblance of the structure or space within which she is positioned. The lighting appears to be from a vertical source, which Cameron used a lot in the early years of her photography. The photograph is cleverly conceived, but I don't know how much that was accident and how much intention.

WN: The wonderful, curving line at her shoulder on the left side of the picture is like a drawn line that somehow relates elements of photography to the traditional process of drawing. Her friend John Herschel made hundreds of camera lucida drawings, and she would have recognized the words "the pencil of nature," coined by Herschel's friend William Henry Fox Talbot. That little shape is a tiny fragment of the entire picture, yet it is a very important component.

JD: I always think it is the details that make a great picture, something like that line or the way the light is reflecting off the button. That whole area would become a void if it wasn't there.

JL: Many of Cameron's photographs from 1864 and early 1865 exhibit technical problems. They have more pinholes, and the uneven collodion coatings indicate that she was still working out some of the technique. The way she describes her method in the note about *Annie* is fascinating, because she wants people to know that she does everything.

WN: In 1867 she wrote something to Herschel that is almost identical in its phrasing. She said, "I have no assistant, and the whole process from first to last, including the printing, is all done by my own hand—and all done at Freshwater Bay." An issue for photographers twenty years later was between those who did their own work exclusively and those who hired other people to make the prints. Cameron shows herself as a kind of pioneer, because as far as I know, there's no earlier

record of someone actually making a statement to the effect that "I did the work, and it was hard, and I'm proud of it."

JC: What she's really saying is that her personal effort and achievement here outweigh the interaction she may have had with other collaborators, other teachers. That's a very important statement to be making, whether it's early on in her career or several years into it.

WN: Let's look at another early work, the portrait of Ellen Terry that Cameron titled *Sadness* (pl. 2). When I first saw a carbon print of this years ago in Alfred Stieglitz's collection, I was struck by its character. Once I got to know a little bit more about Cameron, the background wallpaper struck me as being unusual, because I did not recall seeing it used in any other of her photographs. Rejlander is known to have photographed against the same background, which leads to the question of whether he or Cameron was the author of this picture. The image is in the Overstone Album and thus has an implied declaration that she made it.

PR: Cameron signed this negative on Terry's right arm. I assume that if Rejlander had collaborated, they would have both signed it. I can't see that he would have allowed her to sign it alone. The print is inscribed "Freshwater inside cottage." The house that Cameron owned in Freshwater is rather large by my definition, but they did actually call it a cottage. There is work currently being done there; I've been told that workers have found traces of this wallpaper.

JD: Could Rejlander have made photographs there?

WN: He did photograph various subjects there, almost all of them very different from Cameron's pictures.

PR: Rejlander always seems to have a precision about what he takes; nothing accidental happens in his photographs. The backgrounds are always the ones he wanted. I can't see him doing a background like this, with this hazy imperfection.

WN: And on top of that, the negative was imperfect. The emulsion peeled off on the left side near the signature.

JC: Maybe she only had one opportunity to photograph the model, and this was

the best print she could make with the available negative. This picture was supposedly made during Terry's honeymoon at Freshwater, after her marriage to the painter George Frederick Watts, Cameron's intimate friend. I believe Cameron added the inscription to establish where the photograph was taken and to make a biographical statement about Terry.

Robert Woof: If this is a marriage portrait, shouldn't there be a matching one of Watts?

JC: Perhaps, but while Cameron photographed him on many occasions, there is no direct match to this picture. What do you think she was trying to convey in titling it *Sadness?*

JL: The traditional story is that Cameron and her sisters engineered the marriage between Terry and Watts, who was considerably older. When Terry eventually left Watts, he seems not to have had much bitterness about the entire sequence of events. This is speculative, but is this picture Cameron's acknowledgment that perhaps things weren't working out?

There's a lot of sexuality in this photograph, even compared to Cameron's images of children, many of which are very sensual. Particular attention is paid to standard codes for femininity—the unbound hair, the long neck, for example.

JC: There is a feeling of anxiety expressed in the way she tugs on the necklace and props herself up against the wall. I don't know of any other Cameron pictures where a figure is pictured leaning against a wall.

WN: Joanne, your remark about the sensuality of this picture is notable. There is a very skillful use of light that reinforces the sensual element of the content. The light comes off of her cheek and models the lower part of her jaw; it strikes her shoulder and models, almost in bas-relief, that area under her necklace. I don't know whether she is wearing a nightgown or a petticoat, but it certainly doesn't look like the sort of garment that would be worn on the street. Cameron has created an almost deliberately erotic picture but given it a contrary, antipodal title. This is a marriage portrait of a sixteen-year-old girl who has just been turned over to the hands of a forty-seven-year-old man.

JD: She was sixteen here? Oh, God.

WN: We also need to remember that Terry was a recognized Shakespearean actress, and very handsomely paid.

RW: I can't help but think that many of Cameron's subjects, Terry in particular, are actresses. They are called upon to perform. Cameron was a great casting director.

DF: We are saying then that this is not only Cameron's portrait of Terry, but that Terry, an actress, is a part of this collaboration, creating sadness.

WN: This is a picture where verbal language and pictorial language are at odds with each other. Cameron has indicated the content in a very deliberate way in the form of the title, *Sadness*. The pictorial language is phrased to underscore the sensuality of the woman, but the title and some parts of the composition seem to be undercutting that.

We are looking at two very different prints in the Getty Museum collection that originate from the same negative. The one from 1864, in the Overstone Album, has the figure facing right. The other print, a highly restored carbon print made from a copy negative about 1875, has the figure reversed, facing left (p. 111). We can see by comparing the two where the damage on the earlier negative was.

In the restored version, in the area in front of her face, we can see that there was additional damage to the negative after the creation of the original print. Some of the wallpaper is gone; a technician has restored it by retouching the negative, losing part of the pattern in the process. The area where the collodion was totally gone in the original negative has been reconstructed by hand so as to appear as though it's a part of her blouse.

The retouching has also exaggerated some important content elements, making her ring finger, for example, much more prominent. We can see her wedding ring now. In this picture it is on her right hand, but in Cameron's original print it is on her left hand, where it's supposed to be, but barely visible.

PR: We have a copy of the carbon print at the Royal Photographic Society, but it isn't signed. By the time this was made, Terry was much more famous than Cameron. The whole thing has been transformed into a commercial product, the

essential Ellen Terry photograph for people to buy. The original, I think, represents sadness, but the carbon print is definitely Ellen Terry, famous actress.

JC: One of the last things Cameron did before she departed for Ceylon in 1875 was to deposit some seventy of her most important works—a combination of her monumental heads, her figure subjects, and some Tennyson images—with the Autotype Company in London. The idea was to make carbon prints from them to continue sales and to disseminate her work once she was in Ceylon with her family.

DF: Do you think she was aware of the finished product?

JC: The question of the level of interaction she had with the Autotype Company is uncertain. They published a statement about how they had altered her negatives and made them better, but I don't know of any record where Cameron commented on what she thought of their interpretations of her work.

PR: The important thing about the carbon process is that, as an ink process, it's permanent. It does not fade. Unlike a glass negative, it is not easily damaged. Glass negatives could also peel and reticulate; the salt air in Freshwater affected the collodion coating. Photographers at this time were not sure how long their albumen prints were going to last. The carbon prints are generally in as good condition now as they were when they were made in the 1870s.

JC: Yes, the notion of perpetuity is an important aspect of how Cameron perceived her work. After all, this is the image that Stieglitz reproduced in *Camera Work* in 1913. Most people in the twentieth century know of Cameron's work through this carbon print. Interest in her photography was revived through the later prints. She seemed to be very conscious from the beginning of creating a body of work and organizing it for perpetuity.

DF: Cameron registered her photographs for copyright very early in her career, which again is assuring their preservation. Did other people do this at the time?

JL: Wynfield registered his photographs, and commercial photographers also registered theirs.

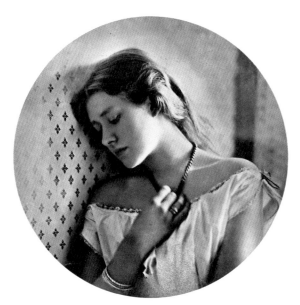

Julia Margaret Cameron.
Ellen Terry at Age Sixteen, circa 1875
carbon print from an 1864 negative.
Diameter: 24.1 cm. 86.XM.636.1.

WN: But so far as we know no other photographer before Cameron reserved the copyright as she did, with an inscription on the front of the photograph.

PR: I think portraits were more commonly registered, because it was hoped that these would be used quite a lot in the future. Very few landscape photographs were registered. The whole purpose was to get a photograph into the public body of work so that it remained there.

JC: She was aiming to generate income from her work, yet she was not a commercially established, studio-based photographer. She worked at a time when there were any number of highly successful commercial portraitists and *carte-de-visite* artists active. Registering her photographs for copyright was a way for her to organize her work, contend with the competition, and define her output.

RW: Did she register everything or just the commercial subjects like Herschel and Tennyson? One of her great gifts was that she had access to these people. Do we know precisely what she registered?

JL: Yes, the forms are preserved on microfilm at the Public Record Office in Kew, England. In the early years it seems that she wanted to protect most of her images— portraits and tableaux—but in later years that changed as she registered fewer works. Some pictures exist that don't match the verbal description in the records, and there are also many prints where she inscribed "registered photograph" but never filed the forms.

PR: I think copyright is also a legitimizing thing that says, "This is art with a capital A, this is serious, this is important; it's registered here, and I've had it printed in the record so it's going to last forever."

JC: Exactly. And in distributing her work so enthusiastically to friends and acquaintances, Cameron was making a further statement about its inherent value. In the same way, writing "from life" and "untouched" and other such phrases on the mounts of the individual prints gave integrity to the work.

WN: Lord Overstone advanced her some six thousand pounds to support her work. We don't know the application of every last penny of that money, but photographic materials were very expensive. Even today we know that photography is a costly way of creating pictures.

DF: Will you tell us more about Lord Overstone?

WN: He was one of the great financiers and art collectors of his time. He shared in common with Watts, and therefore with Cameron, a passion for Italian Renaissance art. His collection of the Italian artists was one of the best in England. Cameron apparently received a good deal of personal satisfaction from the fact that such an important person would not only believe in her work but also be her patron and advance this money in the form of a loan. I'm not sure if the loan was ever repaid, but she did return to him, in thanks, the product of her first two years' work in an album that contains 112 pictures on eighty-nine leaves. The Overstone

Album is a major holding of the Getty Museum and has contributed a number of plates in this book (pls. 1–20).

DF: This is quite an amazing body of work to be completed in two years by a beginning photographer, especially considering that the process itself was far more cumbersome than what someone would encounter today.

RW: Just the physical organization, the compilation and sequencing of such an album, would take significant effort.

PR: And there were several albums being composed concurrently; others were given to Watts and Herschel. The money from Overstone also went to household expenses; the loan was for general as well as photographic expenses. Cameron was learning photography to some extent so that she would have something to give back to people.

DF: The picture we are looking at now, dated 1864, is entitled *Faith* (pl. 7). It shows a woman with two young girls, one of them holding a cross. Mike Weaver, in his book *Whisper of the Muse*, which the Getty Museum published in 1986, as well as in his own biography of Cameron, rather easily finds Christian iconography in a wide range of Cameron's photographs. To what extent was religion important to Cameron in her personal life and in her work?

JC: Very important. She was a devout Anglican. This particular work is part of a series of nine photographs that she entitled the Fruits of the Spirit, based upon a passage in the New Testament that lists elements of the spirit that one is encouraged to follow in life. Cameron attempted to illustrate these modes of behavior.

WN: Toward the end of her life she wrote Henry Taylor, one of her closest friends, a very sharp-tongued letter from Ceylon, saying, "You failed to close your letters with the statement 'God bless you.'" She felt that this formality—each person passing on the blessing—was a fundamental part of social discourse. Only someone of great personal faith and conviction could make such a statement.

RW: She had high expectations of how other people ought to behave, whether it was Tennyson or Taylor. The whole Freshwater circle was interested in other reli-

gions, but they were very comfortable with their own religion too. It seems to me that some of the figures she wanted to depict are both secular and spiritual. *Faith* is obviously more on the spiritual side.

JC: Yes, but—and here's the wonderful thing with Cameron—the models are her maid, Mary Hillier, and two sisters, Kate and Elizabeth Keown, the children of a fortkeeper on the Isle of Wight. We're right back in the temporal world again, even though she's trying to illustrate an idea derived from the biblical text.

PR: I have real problems with some of these. There's nothing about this that really says faith to me, other than the touching of the cross and believing in it. I find this body of work, on the whole, the least satisfying.

JC: But did she have any specific iconography and imagery to look at in order to create these pictures? I certainly don't know of any, so that may be one reason why there is this lack of differentiation between them. They may also appear formulaic because of the short time frame in which they were made.

DF: I wonder if there might be a specific reading to this that would suggest the idea of faith. The girl on the left is holding a cross, the one on the right has her hands clasped in prayer, and the woman gazes heavenward.

JL: In terms of the iconography, this is arguably a Madonna with John the Baptist and Christ. I think it's possible to recognize Weaver's interpretations of the iconography, particularly the nuances of pose, and still be in agreement with Pam's point in terms of their effect.

Cameron's repeated use of the Madonna and Child to epitomize these different virtues isn't remarked upon often enough. This idealization of women could have a religious association or an aesthetic connection to Italian art or could just be a valorization of motherhood.

RW: I talked earlier about Cameron being a good casting director. In a letter she wrote to Anne Thackeray Ritchie she talks about Hillier and says, "Those who don't know you in all your expressions might think them idealized, just as so many think I idealize and glorify my beautiful Madonna [Hillier] but I know all her expressions and know all the beauty and I nearly fixed forever what I saw of you

in the glass house, but then movement comes, because you are not *yet* so practiced a sitter as my Angel of the Tomb."

She thought of Hillier as a great model; she's a star, really. Cameron considered her subjects in allegorical terms, perhaps as Watts did. The two of them set out thinking that words like *faith* or even *sadness* were the proper ideal subjects for pictures. Joanne, I think you know more about Watts than most of us here. Do you feel that his concept of allegory was a rather powerful force on her?

JL: It is a very good point to make, because Watts certainly was very interested in allegory. He also thought that he was representing the reality of his sitters. That phrase crops up in discussions of Cameron's photography and his portrait paintings. There was an idealization, but it was expected to be accurate in some way. They wanted their audiences to recognize that the ideal truly existed in these people.

RW: So would the uniqueness be that no one else in photography was following Watts's approach in respect to subject matter? People who were selling their photographs were in favor of verisimilitude rather than these allegorical themes. Were any other photographers exploring allegorical themes before Cameron?

PR: Rejlander also arranged allegorical subjects, but they were not so religious. He would express moods like despair. I can't think of any Rejlander work where religion is featured, apart from his grand, allegorical *Two Ways of Life*, which is a huge combination print showing what happens if you lead a good or a bad life. That was from 1857 and was undoubtedly fairly widely seen, so there's a very good chance that Cameron would have known it.

JD: One thought I've had, looking at Cameron's pictures, is that they were hard to make because the exposures were so long.

WN: A picture like this would have been made in the length of time that you could remove and replace the lens cap. The purpose of using the glass house as her studio was that she had lots of light and could therefore expose relatively quickly. But setting her subjects up, getting them in position, getting them costumed and ready to be photographed would be very much like what it is today.

RW: It would be excruciating to stay in one position for so long.

PR: She would set up a scene like this and get the subjects all ready, but then she would have to prepare the negative. You couldn't prepare it in advance and have it in your camera and then get the group set up, because the collodion had to be used while it was still sticky. If it dried, there would be no sensitivity, and you'd take a very bad photograph. So Cameron had to set them up; coat the negative with collodion, a mixture of nitrous cellulose, ether, and alcohol; then dip it into a light-sensitive chemical like silver nitrate; and finally put it in the camera. By the time she had done all that, there was the chance that the subjects had moved. I think that's where the time comes in getting a good enough negative to use.

JD: She must have done a lot of praying that these people didn't move.

WN: Let me change the direction of our conversation here briefly and return to one of the unique aspects of the album as a format. We've talked now about four of the albums that Cameron presented: the one that she gave to Watts, which Joanne has worked on and exhibited; the one in the Getty collection, given to Overstone; the album presented to her sister Mia, which is in a private collection in New Mexico; and the great Herschel album, which is in the National Museum of Photography, Film and Television in Bradford, England. There are probably another half dozen that are notable as well. Each has in common an element that cannot be ignored, that when the pictures are mounted on the pages, they fall into a defined sequence that is part of the experience.

This photograph, *Faith*, is located in the Overstone Album on leaf 24. It is preceded by a very peculiar piece called *Isabel and Adeline Somers, My Sister's Children*. This in turn is preceded by another allegorical image titled *Love*.

What is the theme that is unfolding in this sequence? Here children are being invoked in the compositions, and they become a part of something that is larger—family. It seems to me that Cameron has purposely placed all of these studies together, and that the interaction of these children with an adult seems to be the underlying motivation for the organization of the body of work.

JC: There is also a practical aspect to this—children were readily available as models. The examples of Annie Philpot and the Keown sisters demonstrate that beyond the various family members and friends in her immediate circle, local children were used as models for different types of compositions.

JL: Even though Cameron socialized with distinguished people and was able to occupy a position of status within Victorian culture, the roles of wife and mother were absolutely central to her life. Addressing motherhood in her work, using subjects and visual prototypes from religion and painting, was consistent with the values of her society.

DF: Another picture from the Overstone Album is called *The Whisper of the Muse* (pl. 17). It is subtitled *Portrait of G. F. Watts.*

WN: There are also other inscriptions on this print: "Freshwater," "April 1865," and "a Triumph!" This image continues Cameron's moving between truth and fiction, artifice and everyday life. We are invited to think that at Freshwater the sounds of music emanated from people like Watts playing the violin before or after dinner, even though I don't believe he played the violin. It's the gaze of that young child straight in our eyes that somehow connects us to the photograph.

PR: Is the older girl not the muse whispering into his ear? She will enable him to play the violin in the magical, frolicking Freshwater atmosphere.

RW: There is a variant of this picture in the collection of the Royal Photographic Society in Bath (p. 118) where the girl is actually whispering right into his ear. In that sense, the Bath picture clicks more with the title.

JC: It may, but this is a more cohesive and integrated composition. In the Bath picture Watts holds the violin lower down, in both hands, and his head is turned in the opposite direction. Cameron actually registered both versions for copyright; we do not know which of them she considered the greater work.

WN: One of the interesting issues here is the unfolding of the definition of a Cameron masterpiece. She clearly called one early photograph "my very first success." The Ellen Terry portrait became her window to the twentieth century through Stieglitz and is a singularly important composition. Yet, because the negative was damaged, she may have thought of it as a failure. Here we have one that is called "a triumph," yet some of the pictures made about this time that are most interesting to us today she does not comment on as being special to her.

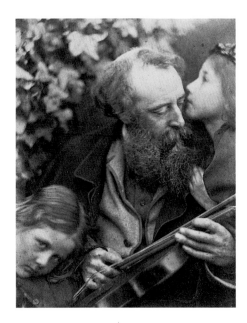

Julia Margaret Cameron.
The Whisper of the Muse, April 1865.
Albumen print, 25.5 × 20 cm.
Collection of the Royal Photographic Society.

JC: I think that her describing it as a triumph is as much about having done justice to Watts—in the picture—as an individual and an important person in her life as it is a reflection of how pleased she was with the composition itself.

DF: What was the relationship between Cameron and Watts?

JL: Watts was the so-called artist-in-residence at Little Holland House, the London home of Cameron's sister Sara Prinsep. He was much esteemed by Cameron and her sisters and by many other people at the time. Cameron identified him as a person with whom she consulted. The album she gave him seems to be the first that she put together after she took up photography.

There was a fairly regular correspondence between them in which he gave her very precise advice. He did not just say, "Forge on, Julia, you're doing great things," but gave specific advice about how she should do her tonal relations a lit-

tle differently, for example. He seems to have been fairly open to using photographs as sources for his paintings, both Cameron's images and those by other makers, so he was a good friend of hers in that way.

JC: He believed that the highest form of art is that which is symbolic. He was also one of the first painters of the Victorian era to actually choose the models for his pictures, for his great "Hall of Fame." He did not have patrons invite him to make their portrait, he selected them, which is precisely what Cameron did. There's a commonality between the two in their approach, in the way they interacted with the people portrayed in their imagery. Somehow I see this picture of Watts playing the violin (pl. 17) as symbolic of Cameron's own desire with her art—she wanted to excel and become a creative force in the new medium of photography.

RW: The subjects we've seen up to now have been placed against dark backgrounds. This is full of surface—the leaves in the top corner, and then the frets of the violin and the curves of the coat and the whiskers and the hair. The dominant patterning is much more sophisticated than what we've looked at up to this point.

JC: I agree. There's a taut energy that unites all the elements in this composition. The scrolling shape of the violin and the flowing outlines of Watts's waistcoat and cape are formal complements to each other. Cameron's visual sense, her drawing with form, is getting stronger and stronger.

JD: This picture seems so compact—it's squeezed into the frame. On the left Cameron has cropped the child's face, which seems so daring to me, especially for the time. And on the right, too, the edge with the violin and his hand is very tight.

WN: I think it's worth noting again the circumstantial evidence we see in this picture about Cameron's technical skills. You'll notice that the emulsion has peeled at the bottom right. It is a physical flaw that is certainly not as damaging as the one in the Ellen Terry portrait, but something that she is accepting as part of the picture. There also is the coating problem right across the girl's face, where the collodion has gone on irregularly and been exposed unevenly. I genuinely believe, however, that Cameron was in search of technical perfection. She wanted to write the equivalent of perfect sentences with her materials. For people in the photo-

graphic world of the time, the flaws in her negatives would have been like sentences that violated standards of good grammar.

JC: She had an unwavering faith in what she created and in her subject. She was not especially interested in the response of the gallerygoers and the reviewers. The spiritual-intellectual idea she communicated was so important to her that it overpowered almost all other reactions to the work.

JL: You could also say that Cameron responded to the authority and the power and the fascination of being able to produce such interesting imagery without having to be involved in that laborious handwork. Her investment in it—"I printed this photograph, I made this photograph"—had to do with the extent to which she considered all of the aspects of this image-making process as subject to her control. Even though we might say that the flawed collodion coating is a little marginal in terms of our twentieth-century expectations of a wonderful nineteenth-century print, she did let it stand. It seems that we could understand that as her saying that she still saw the photograph as characterizing her idea.

WN: What I'm saying here, perhaps in a rather oblique way, is that in declaring this "a triumph," she is prepared to ignore all of the apparent technical shortcomings of the picture. If she had any problems with technique versus expression, she had reconciled herself to those realities by the spring of 1865.

JC: A year later, in the spring of 1866, Cameron acquired a new camera, a larger one that used twelve-by-fifteen-inch plates, and within a year she was producing wonderful, monumental pictures with this new equipment. They were acclaimed in the press as being daring and were praised for their technical competence, which is in contrast to the reputation she had prior to then.

DF: With this portrait of Sir John Herschel (pl. 25) we are moving to a signature style of Cameron's, the close-up heads. This print is from a twelve-by-fifteen-inch glass plate, and the head is essentially life-size. She frequently signed her prints "from life"—this also has that inscription—but this image *is* life.

JC: That's right, and it's someone she's known all her life, near the end of his life. This is a great work of art in itself, but because he died in 1871, it has a further

importance as the last really strong photographic record of him. In October 1866 she wrote to Herschel, "I often think I could then do a head that would be valuable to all ages, and I long to take your photograph with a longing unspeakable."

RW: Did he travel to the Isle of Wight to have it done?

JC: No, she went to Collingwood, his home at Hawkhurst, Kent. Her desire to photograph him was so great that she carted her equipment to the mainland.

JD: Did he have any hesitation about letting her come or wanting to be photographed by her? Or was he completely open to it?

JC: I don't think there's any record of him being resistant. I just assume that since they were lifelong friends he would have been amenable to it.

WN: In order to place this picture in context, we have to imagine that Cameron's friendship and respect for Herschel are as profound as human relationships get. The first year or so of her work is interesting for what is not included as well as what is included; I find it noteworthy that she didn't photograph him in her first year. It seems apparent to me that she deliberately withheld her attention from some of her most important subjects until the moment that she felt confident of her ability to achieve masterful results. They didn't live close to each other, so perhaps there was no opportunity, but at some point she had to decide, "I am ready to photograph the man who is almost as important to me as my husband."

JC: She had to read between the lines of the letters that went between them to gauge the right time to make this picture.

WN: The date of this is April 1867. What had Herschel seen of her work? He had seen the allegories, a lot of pictures of women, and the portraits of Tennyson as "The Dirty Monk" (pl. 18) and Taylor as Prospero (pl. 19), but he had not seen many works that would promise the kind of heroism that we're seeing here.

JC: Cameron exhibited the large prints soon after making them. They were intended to be hung like paintings. She was making a statement to the photographic community that this was a new direction in her work.

WN: What strikes me is Herschel's lack of self-consciousness, and that can be attributed to two possibilities. One is his own character as a human being; he is simply guileless, unlike some of the painters and writers who seem to be projecting a great sense of ego. Cameron has also worked with him so skillfully to ensure that the lighting is perfect. We think of Herschel as possibly the greatest scientist of his age, but I have to imagine that Cameron helped him look like the archetypal image of a genius, that she worked with her old friend to make his appearance what she wanted it to be.

PR: There are at least three different negatives, so it was a long sitting. To me, these are Cameron's first real portraits. They are distillations of the subject; there are no props, just pure Herschel.

JD: The eye contact, the way he looks at you, is really interesting.

WN: Yes. In *The Whisper of the Muse* it was the gaze of the child that animated the picture. Here we just can't get away from the liquid quality of Herschel's eyes.

DF: I think what accentuates it is that the spectral highlight on each eye is just enough off center that he seems to be ready to break eye contact.

WN: I find myself attracted to this picture because of the strength of mind that is projected and the element of power that we see underlying the surface features. It has to do with the shape of the face and the extraordinary genius of lighting it from above so the downward curving of the shadow under his lips and the dimples to either side of his face form an amazing line.

JD: This portrait is very earthy and real. You know she loved that hair and the way it could reflect light in a certain way. It's all so wonderfully drawn. She might have gone over and tousled his hair for him, and she probably liked being able to do that because of their relationship.

WN: I find it unusual that for all of these interesting and celebrated men Cameron photographed—Darwin, Herschel, Carlyle, Tennyson, Hunt—none of their wives are represented. Why Cameron did not feel compelled to photograph any of the women who were standing beside these men puzzles me.

JD: The difference between then and now is maybe that the women then wouldn't even presume to think that Cameron wanted to photograph them, whereas now it would be different. Cameron didn't have to worry about the social obligation of pleasing them, whereas I would definitely worry about it, especially if I were asking somebody if I could photograph them.

JL: There is a paucity of middle-aged women in her photographs. These male friends of hers had very sharp wives, some of whom were Cameron's friends, but she didn't photograph them. She is not known to have photographed her sisters. Cameron reportedly said that no woman should be photographed between the ages of eighteen and ninety, and this idea is basically maintained in her work.

RW: She wrote very long letters to Emily Tennyson and Alice Taylor, so there was an equality of expression given to the spouses of the great men she photographed. But it stopped there; it didn't get translated into works of art.

We talked earlier about the secular and the spiritual in Cameron's imagery, and I think Herschel and the other men we've been talking about would exemplify that for her. They are spiritual people, and yet there's an essence that she can perhaps get out of them.

PR: There is also an element of flirtation about this. They were very serious men, but she was able to hold her own with them.

JL: To go back to the idea of the long sittings and the entire process involved, while making this portrait she had a chance to have this man's undivided attention, to look at him, fiddle with his hair, put the hat on, take the cape off. These portraits have been domesticated as records of the great men, which is very much in keeping with the Victorian idea, but the issue of her power over them is also present.

JD: I think Cameron photographs men very differently than she photographs women in that she's really in control. She's in control of the women, too, but if you're a woman I think it's harder to be in control of men when you're photographing them. When I look at these pictures, it really seems like the men are doing what she is telling them to do. She has a real vision of who they are, and they are playing to her vision.

PR: They like her vision. It makes them look good.

JD: They are familiar with her work, and so they are cooperating. I wonder if she identified with these men. Because she was a woman, she probably could not have the same kind of power or respect that these men had. Maybe she knew inside herself that even though she was as great as they were she could never achieve the same recognition.

DF: The likeness of Herschel was part of a suite of pictures that Cameron created in April 1867. Another of these is the wonderful image of Cameron's niece Julia Duckworth (pl. 26). Why don't we each respond to this portrait individually and let our discussion develop from there.

JD: The first thought that comes to my mind is that it's beautiful, very monumental. The line in her neck, and all the muscles, are incredible, like a tree trunk supporting her head. I like the way it's lit, with the light on the top of her head making a crescent moon shape and illuminating her face. She looks really noble to me. The portrait is reminiscent of some of Stieglitz's pictures of Georgia O'Keeffe, in the way he idealized her and made her look so monumental and strong.

DF: With the Herschel photograph you said you felt Cameron was very much in charge of the situation. Do you get the same feeling with this female subject?

JD: Yes, she was very much in charge. I think she posed people just the way she wanted them. I agree with Robert that she's a great casting director. I think any good portrait photographer has to be able to direct his or her subjects skillfully. Everybody develops a cast of characters they like to use over and over. Duckworth fits perfectly into Cameron's panoply of types.

JC: Duckworth was a very important subject for Cameron. She was photographed many times in a number of different ways. With this particular portrait I find a Puritan coolness about the beauty that is quite different from the Catholic, Italianate sensibility of other of the images of women. There's a wonderful aloofness and reserve about her beauty that has been accented by the skillful handling of light—which you have described, Judy—and this striking profile atop a frontal

bust. That would have been a difficult pose to hold, and problematic for Cameron to execute successfully.

JD: Duckworth is clearly a very strong person physically, which suggests her character is also strong. It's also a classic pose; it could be a cameo.

RW: There certainly is a sense of strength, an incredible support system. The neck is divided into such a symmetrical shape, with that line right down the middle. It is a sort of marble head, with the frill below. The frill looks textured and lacy; the rest of the picture looks so pure in contrast.

DF: I'd say the monumentality of this head results from the camera being positioned below the subject. Photographing up accentuates the neck and makes it even more of a pedestal for the head to rest on. The whole picture hinges on the tension in the neck that was created by the pose.

PR: In my experience, this is a photograph that men fall in love with—they want her. She's aloof and untouchable but so beautiful and perfect. I find it interesting that she is one of the few female models Cameron allows to be who she is. She is not Hope or Despair or Charity, and I assume these are her clothes that she's wearing and not a costume. She's obviously a very intelligent as well as very beautiful woman. She doesn't strike me as someone who could be persuaded to do something she didn't want to do.

JC: She was also Cameron's godchild, so she had a very special place in Cameron's affections. This picture was made when she was twenty-one, the year she married Herbert Duckworth. It is an iconic image of both womanhood and coming-of-age.

RW: This is a person Cameron knows well and understands, but nevertheless she cannot be looked upon as one of those people who has a recognizable body of achievement, as the men certainly have.

JC: She doesn't have it in terms of an identifiable achievement or importance, but she selflessly nursed her invalid mother from when she was a child. After 1870, when her husband, Herbert Duckworth, died, she was very active in social reform work. She was a busy, energetic, intelligent person; very closely identifiable, there-

fore, with Cameron. I think Cameron respected her achievements in terms of womanly virtues and the role of women at the time. Cameron's admiration is evident not only in this picture but also in the many others that she made of her.

WN: Duckworth also has a place in history in being the mother of Vanessa Bell and Virginia Woolf. But what was she like as a human being? According to Woolf, who wrote about her mother in *To The Lighthouse,* this woman, who looks like a Madonna, apparently had a very sharp tongue and was extremely strong-minded.

I find in this picture the remarkable coincidence of beauty and form. Cameron combined the physical beauty of the model with the elements of visual form through her command of light. We saw with Herschel how skillfully he was lighted in order to delineate his features most appropriately. Here the light reflects off the end of her nose in an extraordinary way that is truly like drawing. Cameron really had to know what the light was doing.

DF: I'd like to take the idea of the lighting one step further. Assuming this was done in the glass house at Freshwater, to light a photograph like this really means taking light away, reducing the light coming into the building from certain directions. Cameron positioned her subject where the strongest light was but manipulated it by hanging things up within the studio so that light disappears from the scene, which is completely the opposite of the way somebody would light a scene today.

JC: We've alluded to Duckworth's life as an individual, but I think Cameron was clearly aware of the transformative power of her own art to elevate this everyday person, who was exceptionally beautiful, into a kind of goddess or saint through photographing her. What is also important to remember about Duckworth is that she was used to interacting with artists; she knew how to play her role and transmit this air of divine beauty.

WN: Cameron's objectives at this time, in the spring of 1867, are the reconciliation of the Keatsian dichotomies of truth and beauty, normally thought to be irreconcilable except by the greatest artists. For me, this picture is a remarkable harnessing of the observed elements in nature with the controlling power of the photographer.

It's also worth noting that inscribed on the mount of this image are the familiar phrases "From life, Registered Photograph, Copyright," in that order. This

126

once again reminds us that real life, and not pure imagination, was the fuel for Cameron's pictures. This work can also be seen as the emblem of her downfall. In making it, she created a formula for portraiture—a beautiful person posed against a dark background in profile with a certain kind of light. If she had repeated this again and again under controlled circumstances, she would have had a guaranteed formula for success as a commercial portraitist.

JC: She absorbed herself in the people she placed before her camera—it was not in her nature to remain detached. Therefore, although she gave many indications that she was interested in making money, the actual concept that involved did not appeal to her, because it meant a dilution of her artistic ideals and objectives.

WN: We know that Cameron very systematically cultivated the means for promoting her work. She did what was necessary to make it commercially viable, but she expected to sell her photographs as though they were paintings or prints.

RW: Do we know whether this was sold as Mrs. Herbert Duckworth? Would you go into a shop and say, "I'd like Mrs. Herbert Duckworth"?

PR: In 1868 its price was listed as twenty-one shillings, equivalent to what one would pay for a signed Tennyson. These were the highest priced of any of her pictures. This demonstrates how much she valued Duckworth's portrait—she knew it was beautiful.

JL: There's a passage in Cameron's *Annals* where she describes an imaginary person, a Miss Lydia Louisa Summerhouse Donkins, a "Carriage person" who wanted to have her portrait taken and could arrive "with her dress uncrumpled." Cameron writes, "I answered Miss Lydia Louisa Summerhouse Donkins that Mrs. Cameron, not being a professional photographer, regretted she was not able to 'take her likeness,' but that had Mrs. Cameron been able to do so she would have very much preferred having her dress crumpled." I think her sense was that her portraits were entering public life, but she never trafficked in the market. She wanted to make money on her terms.

JD: Could she have made a living out of selling her noncommissioned portraits? I'm wondering how successful she was at it.

WN: Pam has informed us that, in Cameron's roster of prices, this print was one of the most expensive. My desire to have this picture in our collection went back quite a long time—ten years—before I finally had the opportunity to acquire it. So far as we know, there were only two prints in private hands, suggesting that few were sold. If prints had been sold, more would be available.

JL: I can offer you an interesting alternative argument about that, though. It seems that the most-loved prints are also the ones in the worst shape. They get used up. They're hung on walls.

WN: That's possible. But the Tennysons, by comparison, are more common. A surprising number of her pictures seem to exist in only a few surviving copies. No census has really been made, but I think there are a fair number for which there is only a single surviving print.

DF: This portrait of Thomas Carlyle (pl. 29) is an excellent example of Cameron's reinvention of portraiture. As I look at this, I keep coming back to how sculptural it is. It's in part the lighting, but also the directness. Like some busts by Rodin that are physically a little rough around the edges, the way the light falls on Carlyle's head creates the fullness.

WN: Classical sculpture was among the inspirations for Cameron's art. She was deeply impressed with the Elgin Marbles. She visited them, admired them, and actually composed a few pictures that were pastiches of figures posed in them. It would seem to me that creating a bas-relief sculpture out of Carlyle's face is in keeping with an appreciation for the bas-relief of the marbles she so admired. Your remark on this relating to the sculpture of Rodin struck a resonant chord. It does have a forward-looking aspect, as though this were something much closer to the end of the century rather than mid-century.

DF: The lighting creates an abstracted head that I find very interesting.

WN: It's impossible not to observe the audaciousness of the lighting. Dividing the face right down the very middle was unprecedented in photography. And once again, Cameron created an approach that could have been repeated as a formula.

It is worth noting here that dividing the face in half may relate to a literary source. Two famous Milton poems—*L'Allegro* and its companion, *Il Penseroso*—are about lightness and darkness. I've often wondered if Cameron composed this picture with this theme in mind. The fact that Carlyle dealt with the issue of darkness and lightness in his own writings appears to be relevant also. He was an exceedingly complex human being who seemed to have two sides to his personality. How Cameron has skillfully expressed this division within the man, and at the same time reflected on a famous piece of writing, is a stroke of genius.

JC: Carlyle's writings were very clear-sighted and often aggressively scathing. He was a man of many words and great humor, but he looks very recalcitrant here, purse-lipped. There is a Carlyle quotation that sums up for me the feeling of this picture: "Under all speech that is good for anything, there is a silence that is better, silence as deep as eternity, speech as shallow as time."

PR: He doesn't seem to be a natural part of her circle. There is this photograph of him and a profile, which we assume was taken on the same occasion. He doesn't appear elsewhere or again. Do we know if this was taken in London?

JC: In London, certainly. It was probably made at Little Holland House. Carlyle lived nearby in Chelsea, and I believe he went to Little Holland House and was photographed there, in Watts's studio.

JL: Thinking back on the portrait of Herschel (pl. 25), the amount of distortion of form seen here is astonishing. Because it's Carlyle, we bring our conception of him to it, and that helps hold it together. It's as if there was a license on her part to picture him as ugly, that to do so wouldn't be incompatible with his intelligence.

JC: Carlyle himself described the portrait as "terrifically ugly and woebegone, but has something of likeness."

RW: Carlyle wrote on big subjects, on heroes and hero making, and this picture stands out because of the amount of space that's given to the head in the frame. You are face to face with that very significant head. I don't see this as ugly or handsome, but rather as the attractive head of a sage. He is one of the heroes, one of the men of spirit of the time.

WN: If we compare it to Herschel's portrait and think of these as being representative of two types of genius, Herschel is shown as the understandable genius. Here we see the inscrutable genius. It may be that she did not comprehend his writing on genius or heroes and heroism. When a photographer uses the camera, normally it's to approve of and praise what it is he or she is pointing at. But Carlyle's writing was so contentious, some of it so wrongheaded and difficult, that it strikes me that she may have had an ambivalent relationship to the writing.

JC: The compelling nature of the picture entirely reflects the awkwardness that existed in Carlyle's writings. He was a difficult character, which I think is why the picture has commanded so much attention over the years. It was another that Stieglitz reproduced in *Camera Work*.

JD: I'm really interested in the way you and I see this man, Joanne. When you said that he was almost ugly, it really shocked me, because I think he looks stern, a little angry, and maybe sad. There's a lot of complex emotion in his face, but I still think he is a really handsome man. He might be nasty, but still he's handsome. I wonder if you see the ugliness because of the sternness of this person, or if it's actually the physical features.

JL: I think a nose should be symmetrical, a mouth should have two halves, the chin should be divided up. Cameron undermines those symmetries in this portrait.

DF: *The Rosebud Garden of Girls*, a photograph from 1868 (pl. 34), moves us away from the heroic heads to an image intended as a literary illustration. The title is taken from a line in Tennyson's *Maud*.

RW: Tennyson always felt that *Maud* was among his greatest works; it was a poem that he absolutely loved to perform. It's a long, very dark composition about a love affair that ends badly, and it concludes with the hero going off to war, passionate for patriotism. The importance of the work in the Tennyson household cannot be overestimated. The passage that sets the context of this photograph is from the climax of the piece, where the lover says these lines:

> *But the rose was awake all night for your sake,*
> *Knowing your promise to me;*

The lilies and roses were all awake,
 They sigh'd for the dawn and thee.

Queen rose of the rosebud garden of girls,
 Come hither, the dances are done,
In gloss of satin and glimmer of pearls,
 Queen lily and rose in one;
Shine out, little head, sunning over with curls,
 To the flowers, and be their sun.

WN: It's so easy to think that the photograph is somehow separate from the inspiration, yet as you read that, I couldn't help thinking that Cameron managed to embody a lot of the elements, but not the passion.

RW: What's interesting to me is that she's put a little bit of society into her picture. In the poem we have the lover waiting for "Queen rose of the rosebud garden of girls," but Cameron has photographed this group, which is not part of the poem at all. *Maud* is about a wretched, misguided affair. It's always passion at a distance, and love is portrayed as a state of madness, which we all know is its real state! In the poem, the flowers are actually doing part of the listening for the coming of Maud's feet into the garden. Tennyson wants to capture the idea that somehow the human beings are in a flowered world. There's a lot going on in Cameron's picture, but it's not an encapsulation of the poem.

PR: The picture has nothing to do with the passion of the poem. The Carlyle portrait says more to me about passion than this does.

WN: Cameron clearly must have seen the photographic illustration of books and poems as a potential application for her work. What we're seeing here may be an experiment in book illustration, but the fact that there is no illustrated version of *Maud* must suggest that either she or others concluded it didn't quite work.

JC: It's typical of Cameron's idiosyncratic way of working that she would take part of a line from a poem that had some kind of registration in her mind and immediately associate it with four women—the Fraser-Tytler sisters—who could perform the role suggested by the narrative.

RW: This is an example of Cameron's independence in making statements. She may have had a commercial interest in illustrating Tennyson—which would be a good idea if you wanted to make money—but it seems to me that her own instincts have entered into this picture.

I find these costumes more pleasing than some of the more towel-like arrangements in other of the photographs. They seem more elaborate; perhaps the women had made them themselves.

WN: Would they have been made for the occasion, do you think?

RW: Well, that's my point. You must remember that in the mid-nineteenth century there was the custom of the tableau vivant. At Queen Victoria's residence in Osborne House on the Isle of Wight the princesses performed in tableaux based on Tennyson's poems. After what must have been weeks of preparation, the girls would finally attitudinize and the queen would come to look. Photographs were taken by the royal photographers. Cameron is, in miniature, taking a Tennyson poem and making that the excuse for her photograph.

JL: Given the seriousness with which this poem was taken, would Cameron's use of it be considered a tone-deaf move? Is that a plausible deduction?

RW: Well, Tennyson's attitude toward Moxon's 1857 edition of *Idylls of the King* is indicative. He had a quarrel with the illustrators. In 1859 Ruskin gave this account of Tennyson's complaint: "Tennyson was maintaining that painters ought to attend to at least what the writer said, if they couldn't, to what he *meant*, while Watts and I both maintained that no good painter could be subservient at all, but must conceive everything in his own way, that no poems ought to be illustrated at all, but if they were, that poets must be content to have his painter in partnership, not a slave." My theory is that Cameron may have become caught in this cross fire in a certain way.

WN: The issue here has to do with how removed from the source of the writing the illustrator could be and still maintain the integrity of the work. If we put this photograph into the perspective you've just provided, Cameron was physically the closest human being capable of illustrating this complex and difficult poem by Tennyson, her next-door neighbor and friend. I am able to give myself over to the

process Cameron went through to try to create something that she hoped would succeed, but which we, more than a hundred years later, feel relatively uninspired by. I would call this a noble failure.

DF: This next photograph depicts Charles Norman, Cameron's son-in-law, and two of his daughters, Cameron's grandchildren, after their mother had died (pl. 44).

WN: This is truly a family portrait. It is a very tender picture, if a bit staged. The clasping of the two hands is a conceit that gives the work an emotional impact not many family portraits have.

PR: Since this was taken after Julia—Cameron's daughter—had died, this represents a bonding together of the remaining family unit. I think this is a beautiful photograph; it's one I have never seen before.

JL: It reminds me of *The Whisper of the Muse* (pl. 17) in its arrangement. Just one face is looking at the camera; the other two are looking off in another direction. The proximity of the girls' clasped hands to their father's hand, which is actually quite focused and detailed compared to theirs, is also very touching.

JC: I see his figure almost as a tree trunk at the center of the composition. The daughters are fulfilling their appropriate supportive role, taking the place of the mother. It's important for them to be there with him as little mothers, as progenitors of the next generation of Normans.

PR: They are forming this kind of angelic, enveloping cocoon around him. This is the concept of family again, back to the children and how important they are to Cameron. The whiteness of their clothes cannot be accidental; these little creatures have almost come down from heaven.

JL: It's curious that the son isn't included, though. It's as if the daughters have to shoulder this particular burden. It's a double loss for them, because they've lost their childhood as well as their mother.

JC: Ironically, Julia Norman died in childbirth. She had six children, but I've never seen a picture where all of them are seated together in the same group. Cameron clearly worked intensively in July 1874; she photographed the father with two

daughters, a group of four children, and the sisters together (pl. 46). The series was a way of easing her own grief at the loss of her daughter and trying to reaffirm the onward path of their family despite the absence of the mother.

WN: Through this series of pictures Cameron is essentially giving an answer to the question of what she can offer her children and grandchildren to console them. In a way, we're seeing Cameron stretching out through the lens, reaching out with a kind of caress that she might not have been able to give physically. We don't really know what the bonds of affection were between Cameron and her children, but one has the feeling from all of the portraits made of her that she was not a person who could reach out physically.

JC: That is not necessarily true. I've read references in letters where Cameron laments the paucity of physical contact with her sons. For example, in 1873 she wrote to her son Hardinge: "It is months since I have caressed Charlie Hay. I may even say that since his return from Ceylon I have never been able to caress him." So she definitely did like to have physical contact with her children. The caress with the lens was another dimension of her expression.

JL: Yet it is sometimes difficult to correlate Cameron's photography of a sitter with what we know of her affection for the sitter. For example, while there are wonderful letters from Cameron to her daughter in the Norman family archive, Cameron took very few photographs of her. There are some in the Watts Album.

WN: There is also the element of selectivity. Photographers have the power to choose who or what they wish to photograph, and they choose to photograph for reasons that are complex. It's possible that Cameron had other relationships, verbal relationships, with her sisters and her daughter. It's very possible that her life was divided between those people with whom she communicated completely in writing and those people with whom there was another kind of communication.

DF: The last photograph we will consider is *King Cophetua and the Beggar Maid* (pl. 48), which Cameron included in the second volume of her *Idylls of the King*. This was released in May 1875 and included illustrations of some poems that were not actually a part of Tennyson's *Idylls*. Given Cameron's association with Tenny-

son, it is not surprising that she would embark on this series of depictions, but she wasn't the only one who had done so.

RW: Artists like Gustave Doré were doing huge illustrations of Tennyson's *Idylls* with which Cameron's images would be competing. Here we're dealing with a very short poem, "The Beggar Maid." I have a feeling Tennyson had a part in this illustration. He might have felt that *The Rosebud Garden of Girls* was too free; in this work we see some literalness. These are the lines that relate to the picture:

> *Her arms across her breast she laid:*
> > *She was more fair than words can say:*
> *Barefooted came the beggar maid*
> > *Before the king Cophetua*
> *In robe and crown the king stept down,*
> > *To meet and greet her on her way:*
> *"It is no wonder," said the lords,*
> > *"She is more beautiful than day."*

This picture seems to have a very theatrical setting, with the curtains arranged to suggest a stage. Her arms are crossed, and his foot is about to step down. Everything is done with the utmost literality, almost cumbersomely so.

JC: The point still holds that she was trying to create solutions to the narrative problems that were set for her in the Tennyson poems. Remember, she was the first photographer to attempt this. Compared to some of the other scenes that she illustrated, this is relatively minimalist. It's a very plain set, apart from the velvet curtains that are hanging over the black backdrop. It is quite a simple composition, which she has finished off with the clever vignetted effect at the bottom.

PR: But again, there is no passion, is there?

JC: Cameron had a lot of difficulty procuring the right models for the different scenes. In her letters she describes how she wasted a great many negatives trying to re-create particular settings. I think the lack of intimacy and involvement with the models is in part because she was working against time constraints to get all of the plates exposed, printed, and bound into volumes. She is also much further

back from her subject in this photograph than in any other picture we've looked at today. There's a very different concept of space at work here.

PR: It looks like a still from an amateur drama, with the spotlight here at the front.

RW: I think it's clear that there was a commercial reason these images came into being. Cameron was seeing much more of Mrs. Tennyson at this time. My feeling is that circumstances had changed. Tennyson was still very friendly with her, but the sense of closeness that existed between them in the 1860s wasn't quite there anymore. She wrote a letter in 1874: "Alfred Tennyson asked me to illustrate his *Idylls* for this people's edition and when I achieved my beautiful large pictures at such a cost of labour, strength and money, for I have taken 245 photographs to get these 12 successes, it seemed such a pity that they should only appear in the very tiny reduced form in Alfred's volume (where I gave them only as a matter of friendship), that he himself said to me, 'Why don't you bring them out in their actual size in a big volume at your own risk?'—and I resolved at once to do so."

The "big volume" was the commercial proposition. It was a very grand effort. One of its attractive features is the blue paper on which she mounted the prints. It seems to have a significant impact on the presentation; the chocolate brown of the image becomes that much more striking. It's lovely to turn the pages of these bound volumes. If she did this as an act of friendship for Tennyson, it seems to be an enormous amount of work.

JC: It's so typical of her that she should enter into an undertaking that, because of her working methods and her eccentricities, involved a lot more than she had bargained for.

DF: Also, during the time Cameron was making these 245 photographs, she and her husband must have been beginning to entertain ideas of moving to Ceylon. That would present another complication.

JC: She was emotionally and creatively drained, which is probably why she had so many failures in relation to the number of successes.

JL: You could characterize that in terms of high ambition, since she was willing to make that ratio of 245 failures for 12 successes public knowledge. It seems that this

could also be represented as, "I worked so hard."

PR: "And I will only accept perfection."

JL: Right. I think Robert's point about Tennyson's very strong opinions about how artists treated his work is interesting. Maybe Cameron was trying to figure out how to shape things according to him, how he would respond as an audience, how her work was different from Doré's.

JC: Cameron did state in letters that she was trying to outdo Doré. That's staking quite a high claim, because he was one of the greatest graphic artists of the nineteenth century.

JD: I wanted to say something about the fact that she took 245 pictures to get 12 good ones. That's not really unusual, especially when you're photographing more than one person. My experience, and that of almost every photographer I know who photographs people, is that you take dozens of pictures to get a single success, where everyone looks good or their expressions and gestures are just right. It's unfortunate that she was working in an expensive, slow, laborious manner that was so difficult, but the actual number doesn't strike me as being a lot. When I take one 36-exposure roll of 35mm film, if I get a single good image, I'm happy. That would be 360 to get 10, so 245 to get 12 is pretty good!

WN: Cameron had no idea how hard it would be, nor how expensive. Her work was a continuous experiment; she was constantly doing what hadn't been done or what she had failed at before. One way to interpret *Idylls of the King* is that she flirted with illustrating poetry on a number of occasions and may have felt that she didn't quite achieve what she wanted; she was determined to succeed with her *Idylls*. Time has proven that we're still not counting it as a complete success.

RW: She might have been unlucky, then, to have Tennyson as her inspiration, because he had the wrong ideas. Ruskin and Watts were right, it would seem to me!

WN: That's a very interesting point. Cameron suffered under the bad luck of having her chief inspiration as her next-door neighbor. I wonder if that has anything to do with the departure for Ceylon. I have never fully understood why, after years on the Isle of Wight, the Camerons moved to Ceylon.

JC: In terms of her involvement with photography, it seems like a strange turn to make, but I feel that in going to Ceylon, Cameron was returning home. She was a colonialist. She was fully supportive of the empire and what it stood for. Her eldest sons were there, managing the family plantations. There was also the question of money. The Camerons were broke, and the cost of living in Ceylon was much lower than in Britain. The letters that she wrote in the first year or so after the move attest to how contented she was there.

DF: As a conclusion, let's each say a few words about our thoughts on Cameron and maybe even how they might have changed in the course of our discussion.

JD: I would say that my view of Cameron has changed somewhat. After looking at these photographs, I am more aware of the distinction between the two bodies of work: her really strong portrait heads, and the other images. I feel like I come down on the side of the portraits more than ever now. For me, those are the masterpieces. You can feel the people breathing in them, they're so alive. I think they are some of the greatest portraits of all time. The other work can be charming and quaint, but it does not have the overwhelming power of the portraits.

RW: Your reaction is like that of Bernard Shaw, reviewing for the *Star,* where he wrote: "While the portraits of Herschel, Tennyson and Carlyle beat hollow anything I have ever seen, right on the same wall, and virtually in the same frame, there are. . . . childish trivialities."

My view at the end of the day is that Shaw isn't quite right. What I feel is that there is an oeuvre here, and I would agree that she is a great artist, as he says she is. The apparent triviality does matter, because it allows understanding of the greatness of the portraits. The definition comes out of the total body of her work, and you learn how to view even the masterpieces all the more sharply because you have the context of what might be, in some sense, failures. If our discussions brought out certain things we didn't like, I think that the actuality is still strong, and that must have something to do with the photographs themselves.

JC: The principal idea that comes to my mind with Cameron is her unwavering faith, both in herself and in others. This is demonstrated by an ever-present will-

ingness to adapt her experience and skills to new situations. Her work was never realized according to a fixed plan. In part, Cameron's appeal is so strong because her work is dotted with inconsistencies and idiosyncrasies that are evidence of the living process that bespeaks the most serious and daring art.

DF: I have the same kinds of thoughts. I've always been drawn to artists who operate outside the academy or have a clear notion of what they want to do and proceed to do it on whatever level they can manage. I think it has become clear in the conversation today that Cameron did what she did because she had faith in herself and what she wanted her work to be.

WN: For me, one of the themes that has been evolving in these conversations today is a definition of the photographer as a poet and the photograph as a handmade object, not a mechanical thing. The word that may best describe a photographer like Cameron is the word *maker*, descended from the original Greek word, *poietes*, which is also the root for *poem* and *poetry*. Like the poet, the photographer is the maker of an object that doesn't need to have a meaning beyond its own existence, and yet we've been trying hard today to find some meaning in these pictures.

We have talked about how Cameron succeeded in putting together a photograph, how she built a picture. Her connection, therefore, to the present day is one of sharing with some of the greatest photographers of the twentieth century the idea that a photograph is not a snapshot, but a constructed artifact that expresses the thoughts and ideas of the person behind it.

JL: I am impressed anew by the way her work continues to compel attention. I am also impressed by how it continues to require people to search for understandings of the photographs that frequently get a little beyond what they already know.

PR: The visitors who have come to the Royal Photographic Society and looked at Cameron's photographs, who perhaps haven't had these sorts of images in their background, are all stunned. Her pictures work on so many levels, and they cross so many barriers. They are speaking some language that goes beyond the perceptions that individuals from many different cultures have about art. Cameron's photographs have a very powerful effect on people.

Chronology

1838

Weds Cameron in Calcutta. The marriage produces six children: Julia Hay, Eugene Hay, Ewen Wrottesley Hay, Hardinge Hay, Charles Hay, and Henry Herschel Hay.

1839–46

Becomes leading hostess in Calcutta by organizing the social functions of the governor-general, Lord Hardinge, after whom she names her fourth child. Active in philanthropic work; helps raise fourteen thousand pounds toward relief of those suffering from the Irish potato famine. Her husband becomes president of the Calcutta Council of Education and invests in coffee plantations in Ceylon. Herschel corresponds with her about the latest discoveries in photography.

1847

Translates Gottfried Bürger's romance *Lenore* (1773), which is published in London with illustrations by Daniel Maclise.

1848

Moves with the family to England upon her husband's retirement. They settle in Tunbridge Wells, Kent, but gravitate to Little Holland House, the London home of her sister Sara Prinsep.

1815

Julia Margaret Pattle, the fourth child of James and Adeline de l'Etang Pattle, is born on June 11 at Garden Reach, Calcutta. Her father is an official of the East India Company; her mother, the daughter of French royalists.

1818–34

Along with her mother and siblings, makes repeated trips to Europe, receiving most of her education in France while staying with her maternal grandmother at Versailles.

1835

While convalescing from an illness at the Cape of Good Hope, South Africa, meets Sir John Herschel (1792–1871), an astronomer and pioneer in photochemistry. Also becomes acquainted with Charles Hay Cameron (1795–1880), a distinguished liberal reformer. His "Essay on the Sublime and Beautiful" explores many of the issues that are later to become fundamental concerns of her art.

1850

The Camerons move to East Sheen, London, to be near the playwright and civil servant Sir Henry Taylor (1800–1886) and his wife, Alice.

1852

George Frederick Watts (1817–1904) paints Cameron's portrait in oil; the painting, now in the National Portrait Gallery, London, is the only surviving one of her in this medium.

1853

Charles Cameron publishes *An Address to Parliament on the Duties of Great Britain to India in Respect of the Education of the Natives, and Their Official Employment.*

1857–59

The Camerons move to Putney Heath, London. Cameron is recorded as a member of the Arundel Society, founded in 1848 by Prince Albert, John Ruskin, and others to educate and improve public taste in art.

1860

While her husband is in Ceylon visiting their eldest sons and surveying the family's coffee plantations, Cameron travels to Freshwater, on the Isle of Wight, to see Alfred, Lord Tennyson (1809–92) and his family at their new home, Farringford. She buys the adjacent property, comprising two cottages, and names it Dimbola, after her family's Ceylon estate.

1862–63

Oscar Gustave Rejlander (1813–75) visits Freshwater and photographs at Dimbola. In December 1863 Cameron is given a sliding box camera that uses nine-by-eleven-inch glass plates, a Christmas present from her daughter, Julia, and Julia's husband, Charles Norman. Cameron sets out to realize the techniques Herschel introduced to her some twenty years earlier.

1864

At the end of January records her "first success," a portrait of Annie Philpot, daughter of a local Freshwater resident (pl. 1). Cameron works with great energy, compiling albums of her photographs for her sister Mia and for Watts and Herschel. She also prepares photographs for exhibition and sale, entering into an agreement with

Colnaghi's, London, and registers her work at the British Copyright Office at Stationer's Hall, London. Becomes a member of the Photographic Societies of London and Scotland. Displays work at the annual exhibition in London, which she will continue to do almost every year. Exhibits in Scotland and wins an honorable mention.

1865

Presents a series of nine photographs, the Fruits of the Spirit, to the British Museum. Exhibits in Berlin and Dublin. She is awarded an honorable mention in Dublin and a bronze medal in Berlin, but critics dismiss her photographs for their technical deficiencies and unconventional style. In June, sells twenty prints to the Art Library of the South Kensington Museum (now the Victoria and Albert Museum) and provides twenty duplicates for circulation. An additional seventy-three prints are donated later in the year. In July rents Colnaghi's for a one-woman show that includes many of the most important works from the first eighteen months of her career. In August presents an album of photographs to Lord Overstone (1796–1883), her friend and patron. In November has her second one-woman exhibition, at the French Gallery, Pall Mall, London.

1866

Wins the gold medal at Berlin and a silver medal and certificate of honor at the Hartley Institution, Southampton. Rents Colnaghi's and the French Gallery for exhibitions. Purchases a larger camera that uses twelve-by-fifteen-inch glass plates. It is equipped with a Dallmeyer Rapid Rectilinear lens with a focal length of thirty inches. Presents album of photographs to Anne Thackeray.

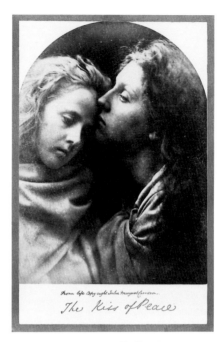

Julia Margaret Cameron. *The Kiss of Peace,* 1869.
Albumen print on cabinet card, 13.4 × 9.8 cm.
84.XM.443.28.

1867

Begins to work intensively on close-up portrait heads with her new equipment. Presents seven photographs to the Pre-Raphaelite painter Dante Gabriel Rossetti (1828–82). At the Universal Exhibition, Paris, is awarded an honorable mention for "artistic photographs."

1868

Rents German Gallery, London, for a large one-woman exhibition and continues to generate sales of her prints through Colnaghi's and a second London agent, Spooner's. Receives payment from Charles Darwin for her portraits of him.

1869

Exhibits in Groningen, Netherlands, where she is awarded a bronze medal. Creates *The Kiss of Peace,* which she considers her greatest work.

1870

Participates in the annual exhibition of the French Society of Photography. Presents a group of her photographs to Victor Hugo.

1871

Displays work in the London International Exhibition. Gives a group of her pictures to George Eliot. Only two images registered for copyright.

1872

Shows prints in the London International Exhibition.

1873

Is awarded a medal for "Good Taste" in her "Artistic Studies" at the Universal Exhibition, Vienna. Exhibits a large group of prints in a one-woman show at 9 Conduit Street, Hanover Square, London. Daughter dies. The Prinseps move to Freshwater with Watts to occupy his new house, The Briary. Only two works registered for copyright; Cameron concentrates on picture sales of existing photographs, especially portraits and allegories.

1874

Writes *Annals of My Glass House*, an unfinished account of her photographic career, not published until 1889. At the request of Tennyson, makes photographic illustrations for *Idylls of the King*. Disappointed at the reduced size and quality of the woodcuts made after her photographs, she publishes her own limited edition with thirteen full-sized plates in December.

1875

In May completes a second volume of illustrations to additional Tennyson poems. Also issues a third, miniature edition, based on the two earlier books. Instructs the Autotype Company to produce new negatives from seventy of her choice images; all prints are made by the permanent carbon process. In October the Camerons leave Freshwater and immigrate to Ceylon, to be closer to their coffee-farming sons. They live near Kalutara, on the southwest coast of the island. Cameron continues to photograph from time to time; her subjects are the domestic help and plantation workers.

1876

In September, Cameron's poem "On a Portrait" is published in *Macmillan's Magazine*. Carbon prints of her Arthurian subjects are exhibited at the Annual Exhibition of the Photographic Society of Great Britain. She is awarded a medal at the International Exhibition in Philadelphia.

1877

The Parting of Sir Lancelot and Queen Guinevere (pl. 47) is reproduced in wood engraving on the cover of *Harper's Weekly*, September 1.

1878

The Camerons make a short visit to England.

1879

Cameron dies on January 26 at Dikoya Valley, Ceylon, after a brief illness. Her husband dies the following year. They are buried on the grounds of St. Mary's Church at Bogawantalawa, near Glencairn, Ceylon.

Henry Herschel Hay Cameron.
*Portrait of Julia Margaret Cameron
by G. F. Watts (1852),* 1890.
Platinum print, 23.5 × 18.9 cm.
86.XM.637.2.

Editor	Gregory A. Dobie
Designer	Jeffrey Cohen
Production Coordinator	Stacy Miyagawa
Photographer	Ellen Rosenbery
Printer	C & C Offset Printing Co., Ltd.
	Hong Kong